Understanding
Northwest
Coast Art

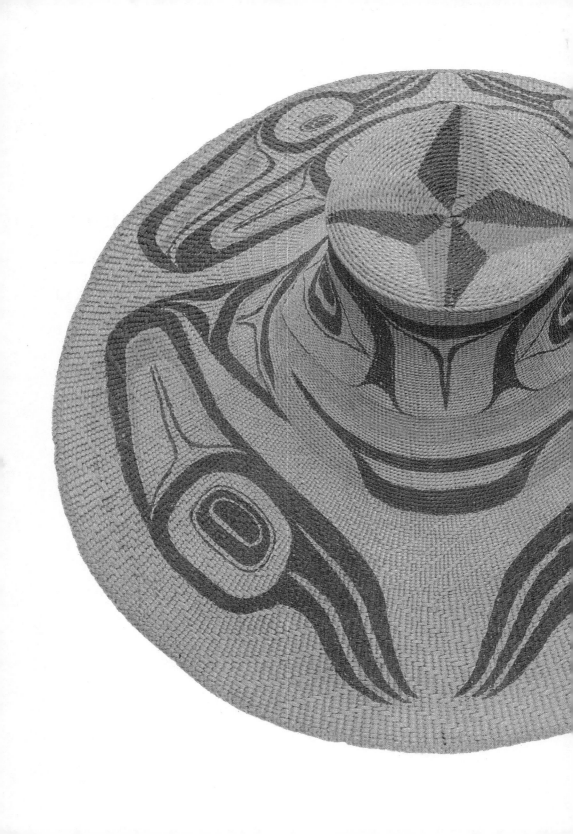

Understanding
Northwest
Coast Art

A GUIDE TO CRESTS, BEINGS AND SYMBOLS

Cheryl Shearar

DOUGLAS & MCINTYRE
Vancouver / Toronto

UNIVERSITY OF WASHINGTON PRESS
Seattle

Douglas & McIntyre Ltd.
2323 Quebec Street, Suite 201
Vancouver, British Columbia V5T 4S7

Canadian Cataloguing in Publication Data
Shearar, Cheryl, 1969–
 Understanding Northwest Coast art
 Includes bibliographical references and index.
 ISBN 1-55054-782-8
 1. Indian art—Northwest Coast of North America—
Themes, motives, etc. 2. Indian art—Northwest Coast of
North America. I. Title.
E78.N78S47 2000 704.03'970795 C00-910176-4

Originated in Canada by Douglas & McIntyre and
published in the United States of America by the
University of Washington Press, PO Box 50096,
Seattle, WA 98145-5096

Library of Congress Cataloging-in-Publication Data
Shearar, Cheryl
Understanding Northwest coast art : a guide to crests,
beings and symbols / Cheryl Shearar.
 p. cm.
Includes bibliographical references.
ISBN 0-295-97973-9 (alk. paper)
1. Indian art—Northwest Coast of North America—
Dictionaries. 2. Indians of North America—Material
culture—Northwest Coast of North America. 3. Indian
art—North America—Dictionaries. 4. Symbolism in art—
North America—Dictionaries. I. Title.
E78.N78 S446 2000
704.03'970795—dc21 00-023450

Design by Val Speidel
Front cover photograph of a woven cedar bark hat, hand
painted with a Frog by Haida artist Charles Edenshaw,
Canadian Museum of Civilization/Musée Canadien des
Civilisations, CMC VII-B-899 (S92-4284)

Printed and bound in Canada by Friesens
Printed on acid-free paper ∞

We gratefully acknowledge the financial support of the
Canada Council for the Arts, the British Columbia Arts
Council, and the Government of Canada through the
Book Publishing Industry Development Program (BPDIP)
for our publishing activities.

All works of art are reproduced courtesy of the individual
artists. All historical photographs are from the National
Archives of Canada (NAC).

Contents

Acknowledgements 7

Introduction: The Art and Culture of the Northwest Coast 9

PART ONE **Dictionary of Crests, Beings and Symbols** 13

PART TWO **The Basics of Northwest Coast Art** 121

 Design Conventions 123

 Design Elements 129

 Cultural Groups and Art Styles 133

Selected Bibliography 141

Acknowledgements

Thanks and praise to the inspired artists, poets, shamans and philosophers of the West Coast and beyond.

I am grateful to the many artists who allowed me to reproduce their works in this book. I am also greatly indebted to the many dedicated researchers and writers throughout the years whose works I used as the basis for compiling this book.

To all the spirits at Spirit Gallery in Horseshoe Bay, including Erin, Judy, Joanie, Gabriel, Christina, Deirdre, Donal: thanks for all the support, laughter and treats. And thanks to Barry, for the many valuable books.

To Will: your currents blew me in the right direction, and I thank you for this gift.

Eternal gratitude and love to my mother, my father, my sister and brother, my husband and all my many relations.

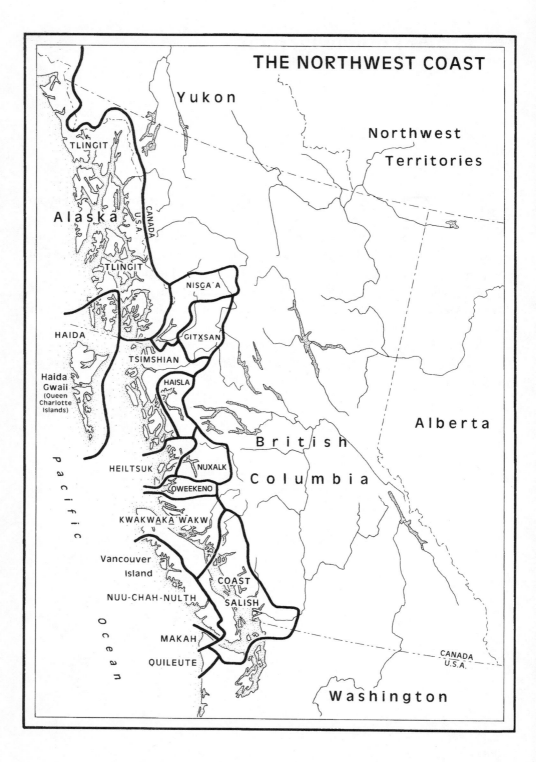

THE NORTHWEST COAST

Yukon

Northwest
Territories

TLINGIT

Alaska

CANADA
U.S.A.

TLINGIT

NISGA'A

HAIDA

GITXSAN

TSIMSHIAN

HAISLA

Haida
Gwaii
(Queen
Charlotte
Islands)

Alberta

British

Columbia

HEILTSUK

NUXALK

OWEEKENO

Pacific

KWAKWAKA'WAKW

Vancouver
Island

NUU-CHAH-NULTH

COAST

SALISH

Ocean

MAKAH

QUILEUTE

CANADA
U.S.A.

Washington

Introduction:

The Art and Culture of the Northwest Coast

Today, Northwest Coast First Nations art is experiencing a phenomenal period of renewed growth. More than a dozen First Nations, each with distinctive cultural characteristics, inhabit the Pacific Northwest Coast between Alaska and Oregon. Within these nations, smaller subgroups exist, also with distinct cultures.

Among all these nations, however, art and the creation of artifacts are intimately connected with religious and social ceremony, with personal and familial status, with history and myth, legal and political systems, and shamanism. Due in part to a hospitable climate and environment, many communities were wealthy enough for some members to devote their time to artistry. Their mastery of art ranks high among the great human collective achievements.

Two institutions central to the culture are the potlatch and various elaborate dance ceremonies, which traditionally occurred during the winter months, after people had finished the bulk of their food gathering and preserving. Artists and performers spent many hours preparing for and rehearsing a wide variety of presentations, ceremonies and entertainments.

The potlatch is the most significant social, cultural, legal and political ceremony, held to mark important occasions: birth, marriage, death, the transfer or inheritance of property such as titles, names, resources, masks, songs and dances. These were all proclaimed in speeches to the guests, who were expected to witness and remember, and were paid with gifts and feasts of food. The more lavish the food and gifts, the more respect earned for the hosts.

The dance ceremonies (many of which are still intact) initiated young people in elaborate rites of passage that introduced them to their responsibilities in the community. Both the potlatch and Winter Ceremony events also offered the opportunity for people to honour their crest and ancestor beings, retell myths and legends, perform songs and dances, and assert or reassert their status. The ceremonies involved the use of regalia such as masks, costumes, props and other paraphernalia.

The early years after Europeans began arriving in the late eighteenth century saw an increase in art production. Trade with foreigners stimulated the culture and the economy in a number of ways. The trade in sea otter pelts resulted in chiefs and individuals becoming far richer than in pre-contact times. In some areas, the "new market" was recognized and explored: the Haida, for example, began trading argillite carvings with sailors. Within

the cultures themselves, patronage of artists grew, along with the new surge of wealth, and by the 1860s, some villages could boast of as many as seventy totem poles.

These heady times were followed by low, and in this case the lows were devastating. Diseases introduced by the newcomers decimated a large percentage of the indigenous population.

The new governing society of white people found the potlatch ceremony particularly incomprehensible, and in 1885, the Canadian government banned the potlatch. The art suffered a terrible blow with this decision, as the need for ceremonial regalia and props dropped off dramatically.

The now infamous residential school system weakened the culture further, as the government attempted to assimilate Native children by removing them from their families, relocating them to faraway institutions, and forbidding them to speak their own tongues. The residential school system made the transference of traditional skills and knowledge very difficult.

The spirit of a people is strong, however, and resistance was inevitable. Potlatching continued underground, though many songs, dances, legends and histories were irretrievably lost.

Ironically, during this period of cultural oppression, the outside world began to recognize the beauty and power of Northwest Coast art. A number of European artists, including Picasso and Matisse, found inspiration in so-called "primitive art," and helped to bring recognition to Northwest Coast art. Famous European anthropologists, likewise, were publishing works and bringing home items that stimulated interest in and appreciation for Northwest Coast cultures.

A major revival of Northwest Coast art began in the 1950s. As a result of the demands on artists working within the highly formalized traditional conventions, the art revival inspired a concurrent cultural revival. Myths, songs, dances, ceremonies, and histories were rediscovered along with art traditions.

Historically, artists were expected to adhere to the rules of composition and property rights. The rights to depict and display beings and legends, as well as to perform certain songs and dances, were, and in some cases still are, jealously guarded by the owners. Such rights might be inherited, stolen in war, traded, purchased or endowed as rewards or gifts.

The rules today are less strict, and extensive borrowing, adaptation and innovation exists. However, many artists choose to research and pursue the artistic styles and images of their own cultural heritage, and some prefer to depict only those crests that are rightfully theirs or belong to people who commission works. Disputes surrounding these rights and privileges may arise, but in general, the cultural climate is one of support for artists who work outside of their particular tribal affiliation.

Today, the art continues to evolve as artists respond to the demands of the art world while they strive to honour the dignity and integrity of both their cultural and personal visions.

These pages offer an alphabetically arranged list of words and explanations relating to Northwest Coast First Nations art and representations of crests, beings, elements, customs and symbols, along with some of the major ceremonies and the types of decorated objects.

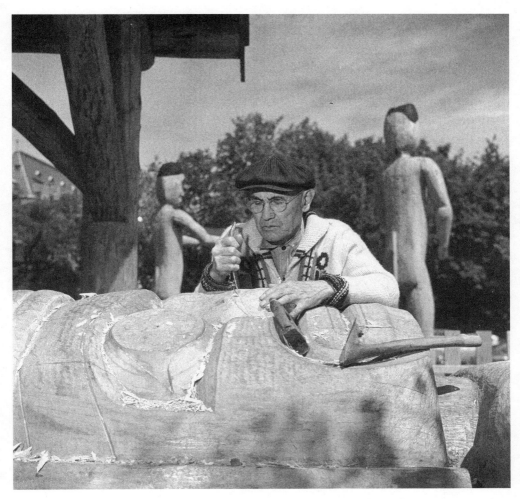

Kwakwaka'wakw artist Mungo Martin working on a pole, with his carving knife and adzes in foreground, 1957. He passed on carving traditions to many young artists. CHRIS LUND PHOTO, NAC PA-166773

This is an introductory guide—it is not intended to be, nor could it be, comprehensive or definitive. Northwest Coast artists (and in some cases the individuals for whom they create works) are the only truly valid authorities regarding the intended function and meaning of a piece. Many, many more crests, beings and stories exist than could be included in a basic introduction such as this book.

Animal Kingdom, print by Richard Hunt (Kwakwa̱ka̱'wakw):
(left to right) Wolf, Grizzly Bear, Beaver, Cedar Man,
Octopus, house, Raven, Whale, Killer Whale, Thunderbird.

Dictionary of Crests, Beings and Symbols

Words in *italic type* indicate
cross-references.

A

abalone shell

□ The abalone is an edible mollusc whose shell has a colourful iridescent lining. The species native to the Northwest Coast is northern abalone, but from early times, Northwest Coast inhabitants preferred the more colourful California abalone, which they acquired through trade. Today, northern abalone is protected, so abalone shell is imported from New Zealand, and, as in past generations, from more southerly American climes.

Pieces of abalone shell are often used as decorative inlay in works made of *wood*, stone or metal. Abalone shell is also fashioned into buttons, beads and jewellery. Historically, a high-ranking woman might own large abalone shell earrings.

Anuwak'xnm

□ Anuwak'xnm is a Nuxalk supernatural creature who, at the start of the *Kusiut* dance (part of the *Winter Ceremony*), leaves the distant village of the Salmon People and travels by magic canoe up the Bella Coola River to the annual gathering of spirits.

arbutus

(madrona)

□ The tree known as arbutus in Canada and as madrona in the United States is a broadleaf evergreen that grows along ocean shorelines from British Columbia to California. It has dark green leathery leaves, strong curvaceous limbs and a papery soft bark, which starts a pale green and ages to a deep coppery red. The wood is very hard but requires careful drying and skilled handling to be useful for carving. Although not frequently depicted in the traditional art, the arbutus appears more often in the modern art.

In one Coast Salish version of the great *flood*-survival myth, the landless drifting ancestors tied their canoes to a great arbutus atop a mountain on Vancouver Island, in order to secure their attachment to their homeland. In gratitude, the Saanich people of the Coast Salish nation created a taboo against the use of arbutus as firewood.

Salish lore also teaches that the roots of the arbutus are responsible for holding the world together. Today, these precious trees are in danger due to human encroachment and disease. People must try to protect the arbutus, for it is one of the entities keeping the world whole.

argillite

□ Argillite is a variety of shale, a soft stone used for carving, particularly by Haida artists. It is a very dark-coloured, compact rock containing silica and having no slaty cleavage. On the

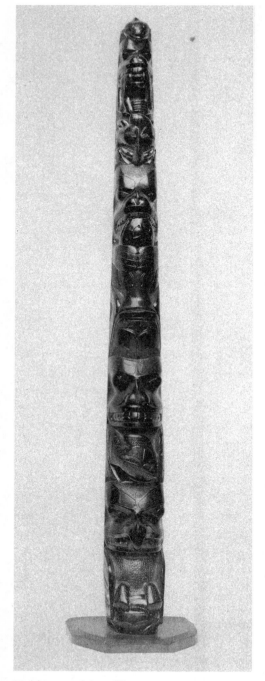

Model totem pole in argillite. EDWARD S. CURTIS PHOTO
(DETAIL), NAC C-003104

coast, argillite is rare; the primary source is a
single quarry named Slatechuck on Haida
Gwaii (Queen Charlotte Islands).

Prospectors searching for copper and coal
in the 1820s discovered this argillite deposit,
and Haida artists ascertained that this newly
discovered resource could be worked with less
difficulty than bone or ivory. (Argillite is like a
hardwood—the islands lacked hardwood trees,
though yew is often harder than many North-
west Coast hardwoods and was often used by
Haida carvers.) Since then, carvers have used
the stone to produce articles for sale.

Argillite items include *pipes*, model *totem
poles* and *houses*, sculptures, *jewellery*, bowls,
plates and small boxes. Today, many Haida
carvers use the stone to produce small items
of jewellery, miniature poles and small sculp-
tures. The larger, older works are valuable, and
those not already in museum collections are
sought after by dealers and collectors.

Atłaḵim

☐ The Atłaḵim, the Dance of the Forest
Spirits, is one of the *four* main dances that are
part of the *Winter Ceremony* of the Kwak-
wa̱ka̱'wakw. In it, a group of up to forty
masked dancers bring treasures from the for-
est. Many of the *masks* have large areas covered
with white *paint* and feature forest motifs and
materials. Traditionally, Atłaḵim masks often
were burned after the ceremony, so they were
sometimes crudely made. The masks include
people, animals, forest spirits, *ghosts* and super-
natural beings such as *Grouse*, Long Life
Bringer, *Nuła̱mał*, *Frog Woman*, Woman Giving
Birth, *Bullhead* and Mimic. Some of them,
such as *Huxwhukw*, *Crooked-Beak*, *Raven* and
Rich Woman, also appear in other dances.

B

Bagwis

☐ Bagwis is a harmless Kwakwa̱ka̱'wakw being of the *undersea world*. He likes kelp beds and is curious but shy. Usually, he is represented on a *mask*; his two front teeth often cause him to be mistaken for *Beaver*. Sometimes the mask has *Loon* attached to the forehead.

Ba̱k̓was

(Bukwús, Bookwuu, Wild Man of the Woods)
☐ Ba̱k̓was is the Kwakwa̱ka̱'wakw name for a supernatural being who lurks on the edges of forests and near streams, hoping to lure the souls of those who drown or unwitting humans to eat his ghost food, which causes them to become otherworldly, like him. He is the Wild Man of the Woods, the Keeper of Drowned Souls, and children are taught to be wary of him. Those souls captured by Ba̱k̓was are condemned to eternal hunger, misery, wandering and evildoing.

The discontented spirits of drowned souls sometimes accompany Ba̱k̓was, and he is closely related to the *spirit world* where the dead reside.

Ba̱k̓was is identified by a skeletal, humanoid face with deep, round eye sockets; a hooked or beak-like nose; an extended brow; hollow cheeks; and a large, grimacing

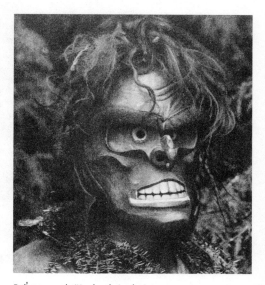

Ba̱k̓was mask (Kwakwa̱ka̱'wakw). EDWARD S. CURTIS PHOTO, NAC C-030920

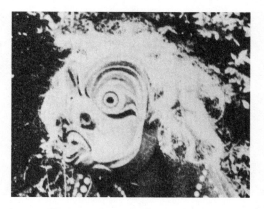

Wild Man of the Woods mask (Nuxalk). CNR PHOTO (*DETAIL*), NAC C-010100

Basket and basket maker (Coast Salish). EDWARD S. CURTIS PHOTO, NAC C-037609

mouth, with or without teeth. There may be twigs and branches in his hair (or as his hair). He often appears in colours that represent the forest realm, such as green, brown and black.

He has counterparts among most groups: *Gagiid* among the Haida, *Pḵvs* among the Heiltsuk, *Land Otter* among the Tlingit, *Poog-oobs* among the Nuu-chah-nulth. B̲aḵw̲a̲s is not related to *Dzunuḵ̓wa*, the Wild Woman of the Woods.

Baleen Whale

(see also whales and whaling)

☐ Baleen whales are often incorrectly identified as *killer whales* (also known as orcas). In depictions, Baleen Whales are distinguished by shorter curved dorsal fins, longer pectoral fins and, in Kwakw̲a̲ḵa'wakw art, spotted body markings.

basketry

☐ Women are the basket makers, with each cultural group producing a number of distinctive styles and motifs. Basketry techniques are also used to make *hats*, mats and bags. All these served a variety of practical or ceremonial purposes.

Traditional basket makers use a variety of natural materials, including spruce root, the inner bark of red and yellow cedar, various grasses and cattails. Many baskets feature woven motifs, which may be representational or abstract. Sometimes, instead of being woven

into the body of the piece, artists used *paint* to add motifs.

Baxwbakwalanuxwsiwe'
(Bakbakwalanoooksiwae, Cannibal-at-the-North-End-of-the-World, Man-Eater)

□ Baxwbakwalanuxwsiwe' is the Kwak̲w̲a̱k̲a̱'wakw name for the wild and terrifying giant monster who feeds on human flesh. He lives in the northern reaches of the *sky world*, and his guards are three fearsome giant cannibal birds (*Huxwhukw, Cannibal Raven, Crooked-Beak*) and *Grizzly-Bear-of-the-Door*. His wife is named *Copper Woman*, or Qominaga (literally, "Rich Woman").

According to Kwakwa̲ka̲'wakw legend, he gave the Northwest Coast people their *Hamatsa* (or Cannibal Dance) ceremony, which in many regions developed into the most elaborate, complex and prestigious of all ritual performances. He personally initiates all Hamatsas by kidnapping them and infecting them with cannibalistic desires.

In depictions, Baxwbakwalanuxwsiwe' is large, and his entire body is covered with bloodstained, gaping mouths. He is personified in dance by the Hamatsa initiate.

Bear head on the side of a grave house at Telegraph Creek, British Columbia, c. 1900. TRANSPORT CANADA PHOTO *(DETAIL)*, NAC PA-082478

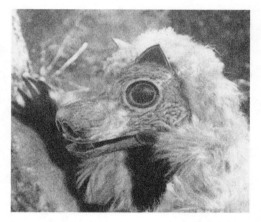

Bear mask at Nootka on Vancouver Island (Nuu-chah-nulth). EDWARD S. CURTIS PHOTO *(DETAIL)*, NAC C-034792

bead
□ As items of personal adornment and symbols of wealth, beads have long been popular. In the late eighteenth century, traders from Europe, Russia and the United States brought a variety of beads to sell to Northwest Coast peoples, who purchased these goods mainly with furs. Amber and red were among the popular glass bead colours, but blue was the most desirable. (Blue was also the colour most coveted in early textile trading.) In some regions, blue glass beads, many of them Venetian in origin, replaced *dentalia* shells as the conventional form of currency.

Coins—especially perforated Chinese coins—and mother-of-pearl buttons were also used as beads by Northwest Coast people.

Bear
(see also Bear Mother, Grizzly-Bear-of-the-Door, Sea Bear)

□ The American black bear is common

everywhere in the region, except on a few of the islands. Grizzly bears live mainly in mountainous areas of the mainland, and one grizzly subspecies, the Alaskan brown bear, inhabits far northern regions. Grizzlies were once found in southern regions, but are now very rare. Kermode bears are a rare white-furred strain of black bear found only in particular isolated regions of British Columbia.

Bear is one of the most prevalent figures in *crest* and shamanic art, as well as in myths. It is considered to be a close relation of humankind, perhaps because of physical characteristics such as size, appearance, and expression, and behaviours such as standing on two hind legs, gathering plants and berries, fishing and nurturing young.

As a close relation, the bear is a link between the human and non-human animal realms, as well as between the secular natural realm and the divine or supernatural. Because of their strength and fierceness, Bears are frequently the guardians, protectors and helping spirits of *warriors*.

Bearskin cloaks are often worn during ceremonial and ritual performances. Bear teeth and claws were used for jewellery, ornamentation and amulets of great power. A bearclaw crown, for example, may be often worn by a *shaman*.

Bear is depicted with a wide mouth, lips and teeth (usually sharp, often displaying prominent fangs); a short, flat, broad snout (often with round nostrils); short squared ears; ovoid eyes; large, clawed feet (which may be turned inward in a pigeon-toed fashion); little or no tail. The tongue is sometimes protruding, extending downward (a protruding *Wolf* tongue generally curls upward).

Both Bear and Wolf depictions may feature stippled surfaces representing thick fur. Sometimes a grizzly bear will have prominent fangs like Wolf's, while a black or brown bear will have teeth but no fangs. Bear and Wolf may look similar, but Bear generally has much less of a tail; a shorter, broader snout; and lower, smaller ears.

Bear Mother
☐ The Bear Mother story is part of the mythology of a number of groups, and is frequently illustrated in the art. A high-ranking woman who is picking berries steps in bear dung and then insults bears. A Bear chief hears the insult and abducts her. She marries the Bear chief and gives birth to twin cubs with extraordinary powers. The unwilling bride is rescued from the Bear village by a male human relative, who is sometimes aided by his dog. Bear Mother and her cubs return to the human village, where the human-bear children become founders of lineages who may thereafter claim Bear as a crest.

Those with rights to display the Bear crest may also address the creatures as relatives and expect to receive an answer, or may develop a reputation as skilled bear hunters.

Beaver
☐ The beaver, well known for its industriousness and building skills, is a common inhabitant throughout the Northwest Coast region. It was once widely hunted for its pelt, and knives with beaver-tooth blades were used before the introduction of iron tools.

Beaver appears in Northwest Coast mythology and is a *crest* in many regions. During the fur trade days, demand for beaver pelts increased as hunters depleted sea otter popu-

lations, and a Beaver crest affiliation some-
times gave individuals the right to trade in
pelts.

According to one myth, the first Beaver
was a woman whose husband was driven, by
the disapproval of his wife's family, to prove
himself a great provider. His hunting trips
were frequent and long, and his lonely wife
took solace in swimming, enlarging her pond
with a dam and building her own water
dwelling. Eventually, she turned into a Beaver.
Their children were Beaver People, like their
transformed mother, and the founders of
human Beaver lineages.

In myth and legend, Beavers keep to
themselves (they are busy!) and care little for
the activities of humans, except when they
feel that their work is disparaged or their skill
insulted. They also give wise advice, so it is
best to listen when they do decide to speak.

Beaver is one of *Raven's* uncles. Raven
stole many treasures from Beaver, including
his house, his watery environment, his berries,
his clever tools and all his salmon.

A magic giant Beaver can cause natural
disasters with one slap of its wide, flat, strong
tail.

In Haida mythology and art, Beaver has a
prominent place. Along with *Raven*, he is inti-
mately connected with *Snag, Sea Wolf, Sea
Bear* and other powerful beings of the *under-
sea world*.

Beaver, along with *Seal*, is a popular design
for bowls. While the shapes of these creatures
lend themselves to bowls, their iconography
also suits this use: symbolically and mythically,
Beaver is an accomplished provider and Seal
represents wealth and plenty.

Beaver may be identified by a bear-like

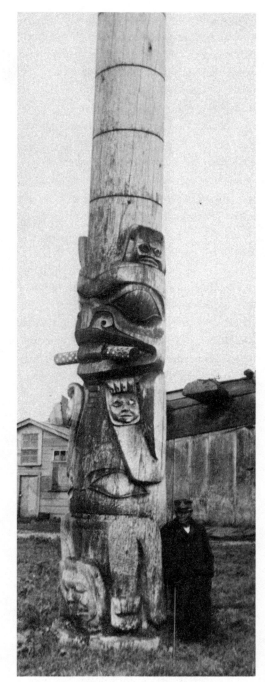

Beaver pole topped with *skils* at Masset, Haida Gwaii,
c. 1890. R. W. REFORD PHOTO *(DETAIL)*, NAC C-060796

21

head; a short, wide, rounded snout; short ears; two large incisor teeth; and a wide, flat, cross-hatched or scaled tail, which generally is flipped up in front of the body. Beaver is often depicted holding a stick in its mouth or front paws, which may be human-like. There may be a secondary face, often human, under the tail.

Another crest, less common than Beaver, which also may appear with large front teeth, is *Groundhog* (or Marmot). But it does not have the crosshatched tail or a stick.

Bee

☐ The bee is one of the few insects to appear in the art. Although not often depicted, Bee does appear, especially in an amusing *mask* that emphasizes its pain-inflicting capability. Bees, *Mosquitoes* and *Wasps* performed as comic interludes in more serious ceremonies, "stinging" people by touching them with the sharp barbs on their masks.

Bees are sometimes cited as spirit helpers to *shamans*. Perhaps Bee's minute size and busy, social nature allows it to access secrets, which its persistent, droning voice passes on to the thankful shaman.

Bee depictions generally feature a short, wide head; large eyes; and a number of pointed spikes sticking out like rays from the face and head. Bee's face is often rounder than that of Wasp or Mosquito.

Blackfish

(see also whales and whaling)
☐ The blackfish is a pilot whale. It appears as a *crest* among Haida of the Eagle *clan*. The naming and identification of whales in Northwest Coast iconography is sometimes confusing. In some areas, for example, *Killer Whale* was once referred to as Blackfish. Contemporary artists use the names Orca or Killer Whale. Blackfish as a name is now uncommon, however, and images of pilot whales are rare.

In depictions, Blackfish resembles Killer Whale, but the dorsal fin and teeth are less prominent and the facial expression less fierce.

blanket

(see also button blanket, Chilkat blanket, Ravenstail robe, Salish blanket)
☐ Northwest Coast blankets are made in a few distinctly different styles and materials, and have a number of traditional functions, both practical and ceremonial.

Traditional blankets made of shredded cedar bark were surprisingly fine and soft. They had many uses, such as clothing, mats and sleeping covers. Sometimes artists used *paint* to put *crests* or story designs on them.

The Coast Salish were renowned for their woven blankets, made from *dog* and *mountain goat* wools and featuring strong geometric patterns.

After contact with Europeans, woollen blankets, particularly those from the fur-trading Hudson's Bay Company, became standard currency in some regions. Traditional crest designs were applied to these trade blankets for use as ceremonial robes. The popularity of foreign-made blankets grew to the point that Native weavers began to abandon their craft.

Today, people continue to produce and use many types of ceremonial blankets in a variety of contexts. Contemporary artists such as Dorothy Grant, Delores Churchill and Evelyn Vanderhoop reinvent and refer to traditional blanket designs.

Blue Jay

☐ The blue jay is also known as the Steller's jay. This chatty, active bird, a familiar inhabitant along the coast, is related to crows and ravens. The Steller's jay was recently adopted as the official provincial bird of British Columbia.

Blue Jay replaces *Raven* as the pre-eminent culture hero and *Trickster* figure in the mythologies of Coast Salish cultures south of Quileute territory in the state of Washington.

In bygone eras, the maternal uncles of a Haida boy might make their nephew eat blue jay tongue in order to improve his climbing abilities. Such practices of sympathetic magic are common in traditional cultures.

bone

(see also Skeleton, skull)

☐ As the longest lasting part of the body, bones were thought to contain the very source and mystery of life. Under certain conditions, a *shaman* could bring animals back to life by working with their bones.

The bones of animals and fish hunted for food and materials were often buried, burned or returned to the water amid prayers for the creature's reincarnation.

box

(bent-corner box, bentwood box, kerfed box)

☐ Prior to contact with Europeans and the introduction of metal tools, Northwest Coast artisans developed an ingenious woodworking technique, which involves grooving, steaming and bending a single wooden plank to form the sides of a box. Three corners of the box are bent and the fourth is pegged, or tied (or more recently glued), and a bottom is added.

Cedar Box, ink on paper, by Clifton Fred (Tlingit): box panel design with Human *(left)*, Bear *(top right)* and Salmon *(bottom right)*.

Artists decorate these boxes with shallow-relief carving and/or use *paint* to add designs, and sometimes inlay surfaces with pieces of shell and metal. Lids are commonly left undecorated, although some feature an inlaid border of *opercula*. Boxes are typically made from *cedar* (red and yellow) or spruce.

The boxes are prized possessions, customarily used to house wealth and ceremonial objects. Storage boxes for more mundane articles might be painted with *crest* and story motifs, but generally do not have extensive carving. Lidless boxes might serve as cooking and food-serving vessels. Mortuary boxes and coffins were also produced this way. People often give *names* to their decorated boxes, tell stories about their histories and treat them as important heirlooms.

In one Haida myth, a nesting stack of magic boxes contains the treasured objects from which *Raven* created the world.

Representations of boxes occasionally appear in the art. When pictured in a composition with Raven, a box refers to the story of Raven stealing *Sun* from another selfish creature—often an old man whom Raven tricks by transforming into a human infant, the old man's grandson—who was keeping it hidden away in a box.

bracelet

☐ Before contact with Europeans, Northwest Coast artisans made bracelets from *copper*, horn or strings of *dentalia* shells. After contact, they made bracelets primarily from silver coins, hammered and then intricately carved with *crests* and mythic beings. Along with carving, repoussé has become a popular modern technique.

A high-ranking woman might wear a great number of beautifully carved bracelets (in copper, silver, and more recently, gold) on each arm. In the past, hosts of *potlatches* commissioned quantities of them at a time, and some old photographs display stacks of bracelets awaiting distribution to honoured guests.

Bullhead

(Sculpin)

☐ The bullhead or sculpin is a spiny, large-headed, wide-mouthed, bottom-feeding fish. This fish is not prized as food, but its presence in the art indicates that its powers are appreciated. It is commonly depicted and plays the role of a spirit helper, frequently carrying *shamans* and other creatures on its wide, strong back. It is also associated with *copper* and treasure. Impressive Bullhead headdresses frequently crown the figures of powerful individuals.

Bullhead appears as a *crest* as well as in shamanic art. Among the Haida, for instance, it is a family crest of the Eagle *clan*.

A Bullhead representation features a short, thick, rounded snout; an elongated, downturned mouth; round, widely set eyes; dorsal spines; and spines over the eyes and nostrils.

Butterfly

☐ Butterfly is a minor *crest* figure (among certain Kwakwaka'wakw *clans*, for example) and sometimes appears simply as decoration. The butterfly is increasingly popular today. Artists such as Robert Davidson and Susan Point, for example, have created modern aesthetic innovations of Butterfly motifs in their work.

In some Haida stories, Butterfly is *Raven*'s companion, acting as a scout who leads Raven to food sources or uncovers the hiding places of other creatures for him.

Butterfly is characterized by double wings and a segmented body. It may easily be confused with *Dragonfly*. Butterfly's body, however, is usually much shorter, and its head and eyes less prominent than Dragonfly's. Sometimes the Butterfly has a humanoid face.

button blanket

(see also blanket)

☐ The button blanket is usually dark navy and displays a *crest* (often appliquéd in red), as well as hundreds of decorative buttons. Today, Melton wool is a common fabric for button blankets, and buttons of *abalone* or mother-of-pearl are popular. In historical times, imported trading blankets were often reinvented as button blanket robes. Some Northwest Coast blankets feature elaborate beaded designs that suggest the influence of sub-arctic or inland styles.

C

Cannibal-at-the-North-End-of-the-World

(see Baxwbakwalanuxwsiwe')

Cannibal Raven

☐ Cannibal Raven (Kwakwakwalanooksiwae or Qoaxqoaxualanuxsiwae, Raven at the Mouth of the River or Raven-of-the-North-End-of-the-World) is one of the three giant supernatural bird attendants of *Baxwbakwalanuxwsiwe'*, the Cannibal-at-the-North-End-of-the-World, in the *Hamatsa* (Cannibal Dance) of the Kwakwa̱ka̱'wakw. He picks out and eats human eyes with his long, pointed beak, and is often accompanied by skull imagery. Some Cannibal Raven *masks* are among the largest ever produced.

Cannibal Raven has a long, heavy beak, strongly curved at the tip, and nostrils with an emphasized flare. The eye area takes up a large portion of the head. The predominant colour is black, with white and red. It has red cedar bark on top of the head and fringes hanging down.

Cannibal Dance

(see Hamatsa)

canoe

☐ The dugout canoe created from a single enormous cedar tree trunk was the traditional

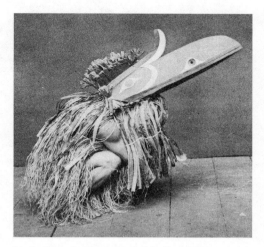

Mask of Cannibal Raven, one of the three giant mythical *Hamatsa* birds (Kwakwa̱ka̱'wakw). EDWARD S. CURTIS PHOTO *(DETAIL)*, NAC C-020861

mode of transportation all along the Northwest Coast, as the mountains made land travel difficult and reduced trade opportunities with interior regions. The canoe is very important to the traditional culture and appears frequently in the art.

Canoe styles vary from region to region, and within a region, several styles and sizes might be produced to suit different purposes such as fishing, hunting, whaling, waging war, trading and voyaging.

Canoe-makers are highly esteemed individuals, who may have important ancestors or legendary heroes named Master Carpenter or

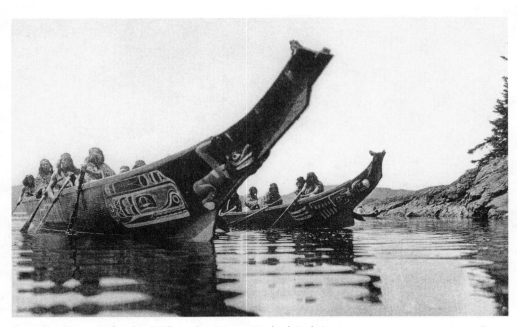

Two canoes: the one in front has *Wolf* carved on its prow (Kwakwa̱ka̱'wakw). EDWARD S. CURTIS PHOTO, NAC C-030189

Master Canoe-builder. Artists frequently use *paint* to decorate canoes on the bow or stern with two-dimensional and/or carved three-dimensional *crests* of their owners, as well as spirit guide images such as *Wolf, Killer Whale* or *Lightning Snake*. As important property, canoes may also have *names*; in some cases, canoe owners have inherited exclusive rights to such names.

Wealthy individuals sometimes purchased impressive canoes from distant tribes. Haida war canoes, which could be up to 18 metres (60 feet) long, were particularly desirable. Nuu-chah-nulth "goose canoes," small vessels used for hunting, were likewise popular among other tribes.

Miniature and model canoes were among the earliest curios produced by Native carvers for sale to explorers, visitors and settlers.

Representations of canoes in the art may symbolize travel, a spiritual voyage, or the function of containment or storage. *Shamans* are said to make dangerous voyages in *spirit canoes* to the *spirit world*, in search of wisdom or lost souls.

A deceased shaman's body might be sent out to sea using a canoe. The shaman makes a final journey to the spirit world in a canoe, which turns full circle on the water to symbolize a crossing of the cosmic axis connecting the various realms of the universe.

cedar
(see also tree, Tree of Life)

□ The cedar reigns supreme among the trees appreciated and utilized along the Northwest Coast. Nearly every part of the tree was used, including wood, bark and roots, to make everything from dwellings and totem poles to blankets, baskets and rope. Two species of

cedar are indigenous: western red cedar and yellow cedar.

Cedar spirits such as Long Life Maker and Sister (or Elder Sister) are spoken to and treated with respect and gratitude, as close relations whose guidance and support is recognized and appreciated.

Red Cedar Bark Dance is another name for the Tseka, the important Kwakwaka'-wakw *Winter Ceremony*. During these rituals, as during the *Guardian Spirit Power Dance* of the Coast Salish, initiates wear large cedar bark neckrings and repeat lyrics that refer to the sacredness of red-dyed cedar bark. The wild, untamed initiate wears hemlock primarily, and changes into a cedar bark costume as taming and purification progresses. The presence of cedar bark reminds people to respect the customs and rules of the ceremonial season.

Shamans, likewise, traditionally wear cedar bark neckrings, which they remove in order to pass around a patient's body in an act of ritual cleansing.

The pre-eminence of cedar trees means that any Tree of Life motif refers to a cedar, unless otherwise specified. Contemporary Northwest Coast artists use cedar images to reflect their deep concern with environmental problems.

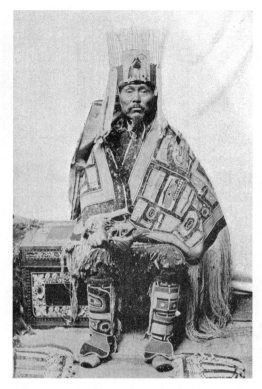

A northern chief in his regalia: *Chilkat blanket* and leggings, Eagle *frontlet*, holding a Raven *rattle*, at Skeena River, British Columbia, C. 1900. DEPT OF INDIAN AFFAIRS PHOTO, NAC C-056768

chief

☐ A chief's title is hereditary and may be claimed through hosting a formal feast or *potlatch*, with the distribution of gifts to guests as payment for witnessing the event. Chiefs ensure the success and succession of offspring and kin through elaborate public ceremonials.

A chief may have authority over a household, a lineage, a village, a *clan* or a region. Chiefly rights and responsibilities vary greatly from situation to situation. The Haida sometimes call their chief, male or otherwise, their "Town Mother."

Today, administrative responsibilities lie with a band or tribal council, often headed by an elected chief.

Chiefs have a prominent place in Northwest Coast art. A chief is customarily the trustee responsible for the group's *crests*, songs, dances and stories, which are among its most valuable possessions.

Chiefs, therefore, are usually shown in

association with crest figures, or as the embodiments of crest figures. When a chief is depicted as a crest creature incarnate, the artist will often reveal its human nature by incorporating some human features such as hands or feet. Sometimes the crest figure is shown in a nurturing, protective stance with a chief, which may express both the ancestral and "helping spirit" aspects of the relationship. *Totem poles*, for example, may have a small chief nestled between the feet and legs of a giant animal figure.

Traditionally, the Nuu-chah-nulth addressed prayers to *Four* Chiefs: the rulers of Above, of Horizon, of Land and of Undersea. Northwest Coast supernatural hierarchies often resembled human social organization.

Chiefly regalia varies among groups. One item is the conical hat, either woven or wooden. Northern chiefs frequently wear intricately woven *Chilkat blankets* and elaborate carved *frontlets*, and carry *rattles*, *Coppers* and *talking sticks* (speaker's staffs). Southern chiefs often wear elaborate headdresses adorned with *feathers*, skins, wool, quills, cedar bark or shells.

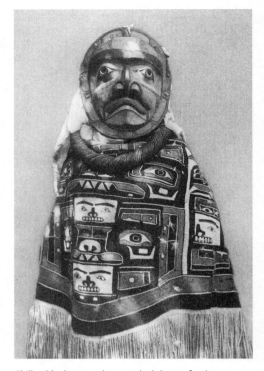

Chilkat blanket worn by a masked dancer for the *Dhuẁláx̌a* (Kwakwa̲ka̲'wakw). EDWARD S. CURTIS PHOTO, NAC C-030919

chief's seat

☐ A chief's seat is a small bench with arms and a back, used by the *chief* on ceremonial occasions. Usually, it is both carved and decorated with *paint*.

Chilkat blanket

(see also blanket)

☐ The Tlingit are renowned for their extraordinary woven five-sided Chilkat blankets worn during ceremonies by *chiefs* and high-ranking people. Chilkat weavings—named for the Chilkat tribe in Tlingit territory—

were worn as robes, aprons, dance tunics or leggings. They have great symbolic power: for example, a Chilkat blanket with a *Sea Bear* motif is considered to be the actual skin of the mythical Sea Bear, somewhat transformed in its crossing of the boundary between the creature's *undersea world* and the *mortal world*.

The Tsimshian people may have been the original creators of the Chilkat techniques and styles. Other coastal groups also learned to produce these blankets, or acquired them through trade.

When a Chilkat blanket is worn, the central part of the design lands squarely upright at the centre of the wearer's back, and the profile faces at either side drape over the

wearer's arms at the front. The wearer may announce his or her *crest* affiliation by entering a dwelling or area backward, crest face first. Dancing the robe causes the long wool fringes to sway rhythmically: one name for the blanket means "fringes around the body."

One Chilkat blanket may take a year or more to produce, woven using cedar bark and *mountain goat* wool, of natural colour and dyed yellow and black. The intricate designs feature geometric grid-like patterns that contain abstracted crest and story figures. High-ranking men were traditionally responsible for the sacred motifs, which they rendered onto pattern boards. Skilled weaving women undertook the manifestation of the design. Scholars have difficulty decoding many Chilkat designs, which are complex and abstract.

The Chilkat weaving technique is unusual because the loom does not have a bottom frame, so that the warp threads are secured only at the top. This allows the weaver to choose to create the textile in vertical sections instead of always moving across the warp horizontally, end to end.

clam

☐ The clam species native to the Northwest Coast include the butter clam, littleneck clam, horse clam, geoduck, thin-shelled clam and razor clam. All of these varieties are edible, and the larger shells were sometimes used as dishes, the smaller ones to make beads and ornaments.

In Haida mythology, *Raven* discovered the first humans in a clamshell and coaxed them to enter the world. Haida artist Bill Reid's famous monumental wood sculpture illustrating this myth is on permanent display at the University of British Columbia's Museum of Anthropology in Vancouver. In some versions of the Haida myth, Raven's sexual intercourse with Clam engenders the world's first human beings.

The clam is not a *crest* figure, but it is mentioned in stories and appears as a decorative motif. Depictions of clams are generally naturalistic, showing the curved shell with linear surface patterns. A human face may appear on the shell to personify Clam. Clam motifs are often employed as space-fillers and supplementary decorative elements in works of art with marine themes.

clan

☐ The clan plays a central role in Northwest Coastal social systems, particularly among northern groups. Tribes are divided into sub-groups called clans. Clan affiliations are determined by birthright (or adoption): in matrilineal systems, a child belongs to the mother's clan; in patrilineal systems, to the father's. People must marry outside their clan.

A great deal of Northwest Coast art depicts *crests*, which express and record clan ancestry, status and privileges, as well as histories of relations between clans. Most clans have inherited histories of myth-time ancestry, attesting that they are descended from supernatural or partly human beings.

cockleshell

☐ Cockles are an edible mollusc, harvested by digging in the sand and mud of beaches. They are a favourite food of *Bak̲wus*, the Wild Man of the Woods.

In a Haida myth, *Raven* is amused when he witnesses the first men copulating with

Carved wooden representation of a Copper on a memorial at a graveyard in British Columbia, c. 1910.
W. H. GIBSON PHOTO *(DETAIL)*, NAC PA-059995

cockleshells, which are consequently impregnated and give birth to women.

A Cockleshell Spirit may be represented by a striated border design, humanoid features and a narrow, long, protruding *tongue*.

Cod

(see also Lingcod)

☐ A variety of cod and rockfish species live in the waters off the Northwest Coast. Many are popular as food, though none compares with the five salmon species in this regard. Codfish occasionally appear in Northwest Coast stories and art.

Cod is generally portrayed with a large, wide mouth; round, wide-set eyes; spiny fins; and a flat-bottomed body. A fin design may be painted on the face. The Supernatural Codfish *mask* has curly horns that indicate supernatural qualities.

copper

(and **Copper**)

☐ Metals were once very rare in Northwest Coast societies, and thus were highly regarded. Copper was the first metal to be used by Northwest Coast peoples, acquired in trade from Native peoples of the Coppermine River in the interior. The traditional practice of producing the objects called Coppers became more common after contact, when European sheet copper became available in trade.

The most important symbol of wealth, power, status and prestige is the Copper, a shield-shaped object made of beaten copper, sometimes engraved with symbols.

A Copper has a rectangular base segmented by a ridged "T" line; the non-segmented top portion of the shield flares beyond the width of this base. No matter what the material, an artifact or motif with this particular shield shape is referred to as a Copper. Jewellers today, for example, create Coppers made of silver and gold.

Coppers are rare and coveted, valuable far beyond the cost of materials and labour. *Chiefs* once purchased sought-after Coppers for many thousands of blankets each.

The wealthiest of chiefs, to assert his superiority, might cut off a piece of a Copper and give it to an honoured guest or rival at a *potlatch*. A Copper broken in this manner did not lose value: on the contrary, such a display increased a Copper's worth. A chief might even throw a Copper into the sea or into the fire as the ultimate sign of superior wealth

and a challenge to rivals to match or exceed the gesture.

The colour of copper symbolizes wealth. Coppers themselves may symbolize light, *salmon*, resurrection, sky, sea or the *undersea world*. The distinctive shield-shaped Copper is frequently incorporated as a symbol on poles (particularly among the Kwakwa̱ka̱'wakw) and on objects of all kinds.

Coppers are sometimes nailed to totem poles, to remind outsiders of the status and strength of a chief, house or village.

A Kwakwa̱ka̱'wakw chief who distributes pieces of a Copper adopts the persona of *Dzunu̱k̕wa*, in that being's male *warrior* aspect, by wearing a *mask* called *Geekumhl* (meaning "chief mask"). Outside of this context, Dzunu̱k̕wa represents wealth generally, and is often associated with Coppers.

After his death, a Tsimshian chief was customarily honoured by the breaking of a Copper by his people, who identified the pieces as the metaphoric *bones* of the deceased, and distributed these among his fellow chiefs.

Copper Maker Woman

(see Talio)

Copper Woman

(Komunokas, Qominaga, Rich Woman, Xaalajaat)

□ Copper Woman is a powerful pan-cultural female spirit. Called Qominaga by the Kwakwa̱ka̱'wakw, she is the wife of the fearsome *Baxwbakwalanuxwsiwe'*, the Cannibal-at-the-North-End-of-the-World. She wears cedar bark clothing, dyed red and white. She is associated with *Frog*, with *Coppers* and with wealth in general.

In Haida mythology, Copper Woman, or Xaalajaat, is the most powerful of the supernatural female beings. Occasionally, in extraordinary circumstances, she has been known to accept a human husband.

Cormorant

□ Pelagic cormorants (also called shags) breed along the Northwest Coast, along with double-crested and Brandt's cormorants. The cormorant is a diving bird, whose ability to both fly in the air and travel underwater leads to its appearance in shamanic contexts. *Shamans* often seek the guidance and spirit power of creatures that can move from one environment to another.

Among the Haida, Cormorant is a *crest* of the Eagle *clan*, and is depicted with a long, flat beak that is squared at the end, rather than tapered like the beak of *Raven*.

cosmos

□ The cosmos of Northwest Coast peoples has a number of distinct, interconnected realms: the *sky world*, *undersea world*, *mortal world* and *spirit world*. The number and names of these realms vary among cultural groups.

cougar

□ Wildcat species such as cougar, lynx, and bobcat inhabit regions of the Northwest Coast but rarely appear in the art and mythology. This may be because by nature they are quiet and reclusive (unlike, for example, bears, and to some degree, wolves).

The Nuu-chah-nulth have stories of a backward-walking Supernatural Cougar, with a tail like a sword.

Occasionally, the elusive cougar appears

in contemporary art, with a somewhat bear-like head but a longer body and a long, lean tail.

Coyote

□ Coyotes are inhabitants of the far southern reaches of the Northwest Coast. Coyote, as *Creator* and *Trickster*, is a major figure in the mythologies of Native peoples from the plains and southwest regions of North America.

In Northwest Coast mythology, Coyote may display the cleverness and guile of a Trickster, though in a less prominent way than *Raven*. Although Coyote occasionally appears in stories, depictions in the art are not common.

Crab

□ Edible coastal species include the red rock crab, spider crab, Alaska king crab and Dungeness crab. In some coastal cultures, *Frog* is called Crab of the Woods or Forest Crab.

In Kwakwa̱ka̱'wakw myth, Supernatural Crabs are sometimes associated with *Tuxw'id*, a female *warrior* spirit. Its natural armour makes Crab a suitable familiar for the valiant fighter.

Crab is a rare figure in the art. It is shown with squared body, small eyes, prominent claws and numerous legs.

Crab puppets carved out of wood and with hinged legs were cleverly rigged so that they appeared to scuttle unaided across the floor during the performance of the *Winalaga̱lis* (War Spirit) dance featuring Tuxw'id.

Crane

(see also Khenkho)

□ The crane is a long-billed, long-necked, long-legged bird. Crane is a border-dwelling creature that is at home in the sky, on land, or on water. It is sometimes associated with *witches* in Northwest Coast tradition.

Creator

□ Many Native people in the Northwest Coast emphasize that their ancestors believed in a supreme being who is ultimately responsible for the creation of life. Animism is also prevalent in traditional cultures: all things, animate and inanimate, are believed to have spirits. But it is incorrect, and offensive to many, to describe Northwest Coast peoples as totem-worshippers who pray to animal gods. These spirits may be better described as helpers and guides and coinhabitants.

Many Northwest Coastal people converted to Christianity after the arrival of the missionaries, and some artists today find creative ways to simultaneously honour both newly introduced and traditional beliefs and rituals.

Creek Woman

(Djilakons, Gilakons, Jilaquns,
Lady of the Frogs)

□ Creek Woman is a Haida female ancestor, and one of the wives of *Raven*—he won her hand and brought her to Haida Gwaii (Queen Charlotte Islands) under false pretences, using treasures that he stole from his uncle, *Beaver*. She and her cronies live in stream headwaters, and her primary familiar is *Frog*. She is a guardian of forest spirits; insulting the forest and its inhabitants will bring down her full, fearsome, destructive wrath. She is merciless in her vengeance, once provoked. Her *mask* is a human female portrait, often wearing a *labret* (a lower lip ornament) to indicate high rank.

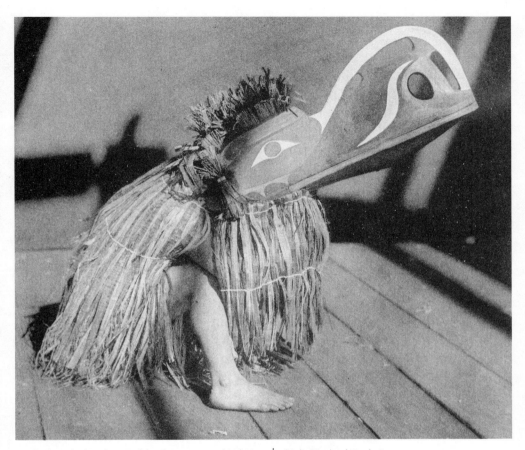

Mask of Crooked-Beak, one of the three giant mythical *Hamatsa* birds (Kwakwa̱ka̱'wakw]. EDWARD S. CURTIS PHOTO, NAC C-034794

crest

☐ A crest is an image representing a family, a *clan*, a lineage, or a high-ranking individual. Crests are often valuable possessions, and historically people carefully guarded them as their greatest treasures and heirlooms, along with the stories, songs and dances associated with the images. Crests can be human, animals, inanimate objects, aspects of the environment, mythical beings or combinations thereof. Crest *masks* and paraphernalia embody the spirits of ancestors, both natural and supernatural. Rights to crests are granted, asserted and renewed through ceremonies such as *potlatches* and performances displaying masks and costumes. Today, some artists depict images in addition to those they have inherited, but many artists still focus primarily on their own crests and stories.

Crooked-Beak

(Crooked-Beak-of-Heaven, Crooked-Beak-of-the-Sky, Galokwudzuwis, G̱alu̱kwiwe', Gelogudzayae)

☐ Crooked-Beak, a monstrous human-eating bird who inspires great fear, is one of the *Hamatsa* (Cannibal Dance) ceremony's three giant cannibal birds. The other two birds are *Huxwhukw* and *Cannibal Raven*, and all three are attendants of *Baxwbakwalanuxwsiwe'*, the Cannibal-at-the-North-End-of-the-World.

On *masks*, Crooked-Beak's head is squared, the nostrils are widely spaced and flared, and the expression is generally aggressive. The beak is always short and wide, and topped with a large, dramatic, curved appendage. Such prominent curved protuberances are a mark of supernatural power.

Interpretations differ widely in their treatment of the dramatic curved beak for which the bird is named. Legendary Kwakwaka'-wakw artist Willie Seaweed, whose work has inspired many artists throughout the twentieth century, is famous for his interpretations of Crooked-Beak.

Crow

☐ Crows are often mistaken for ravens, as both are glossy jet black, straight-billed, short-legged, raucous and cocky. However, the crow is much smaller than the raven.

Crow plays a much, much smaller part than *Raven* in Northwest Coast mythology and art. Crow does, however, occasionally appear in stories, and is a minor *crest* in some regions (among the Haisla, for example).

Crying Woman

☐ Crying Woman is a being known primarily among northern groups. Various stories explain her tears: the loss of her children is one reason that is common to many versions. A chance meeting in the forest with Crying Woman is said to bring luck to a person.

Crying Woman appears on some beautifully carved poles, on which her tears make long trails down the length. The tears may take the form of beings from the particular story being depicted, such as her lost children.

On Haida poles, the figure called Crying Woman actually depicts a mythical Tsimshian chief whose eyes hung down in front of his body.

D

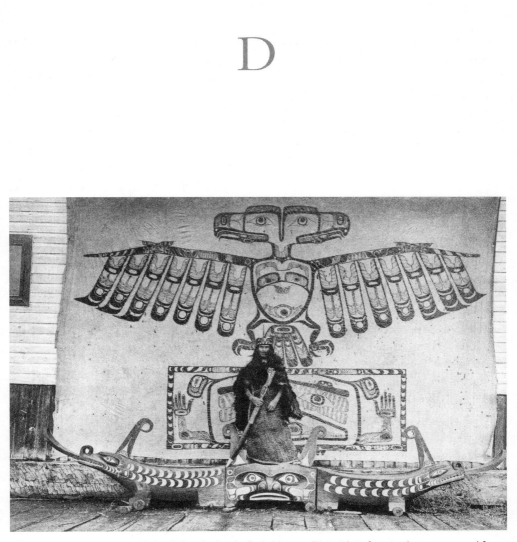

Painted dance screen with double-headed *Eagle*; the chief is holding a *talking stick*. In front is a huge, segmented feast *dish* in the form of *Sisiyuɫ* (Kwakwa̱ka̱'wakw).

dance screen

(dance curtain, house screen)

□ A dance curtain or screen is a panel, usually made from wood or cloth, that closes off a section of a house or stage to conceal the preparations of performers. The surface is generally decorated with *paint* and/or carved with images representing *clan* and family crests, and typically the crest being is frontally depicted.

The panel may feature a hole large enough for a person to pass through, and this hole will often be located near the abdomen of the crest being. These holes suggest the intimate relationship between the living and the dead by representing the birthing process; for example,

a *chief* passing through the hole is perceived as entering into or emerging from the womb of his mythic ancestor.

In Kwakwa̱ka'wakw dance curtains, the hole is sometimes the mouth of *Baxwbakwalanuxwsiwe'*, the Cannibal-at-the-North-End-of-the-World.

death
(see also bone, skeleton, skull)

□ Death—which involves the inheritance of property, rights and titles by kin—traditionally requires more ceremony than any other event in the cycle of life. The extent of the ceremonies varies according to the rank of the individual. To honour the deceased and publicly acknowledge the transference of property, rights and titles, memorial art is created, and dirges, or "crying songs," are composed.

Some tribes put their dead in carved mortuary *boxes* placed in trees, in grave houses, in caves or upon high poles. Grave sites are traditionally well marked and even fenced, and decorated with *crests* and memorials. Graves are sacred and powerful sites that can bring great harm to those who are disrespectful or careless.

After a time, souls are said to achieve *reincarnation* within the same family. Children are carefully observed for signs that can help to reveal past life identities.

In some Northwest Coast languages, the depth and strength of faith in reincarnation is shown by use of the same word for both a grave box and a cradle; baby songs and mourning dirges also may be interchangeable.

Drowning is widely feared as the worst form of death, for the souls of the drowned are often captured and transformed by powerful and malicious creatures. The drowned are likely to become unhappy, troublesome *ghosts*, condemned to a miserable limbo wherein they feel compelled to prey on vulnerable members of their own (former) kind.

In the art, death may be indicated by wounds; closed, nearly closed, or empty eyes; slack, protruding *tongues*; or *skulls* and skeletal imagery. Much of this imagery also appears in shamanic contexts, as *shamans* frequently enter trances and are the masters of death and rebirth, as well as travellers to the *spirit world* of the dead. Much of the art concerning death is devoted to the universal concept of overcoming death through the survival and strength of the spirit or soul, and the attainment of unity with forces greater than the individual.

Death-Bringer
□ Death-Bringer is a fearsome Nuxalk spirit depicted with a broad nose, deep eyes, wild hair, bulging forehead, and fur clothing.

In Kwakwa̱ka'wakw tradition, a death-bringer is a supernatural weapon that the bearer points at a living thing to kill it.

decorated objects
□ Traditional decorated objects include: adzes, amulets, aprons, *basketry*, *blankets*, *boxes*, *canoes*, capes, *chief's seats* (settees), clappers, *Coppers*, cradles, crossbeams, crowns (see *shaman*), *dance screens*, *dishes*, dolls, *drums*, fish hooks, frontal poles (see *totem poles*), *frontlets*, grave markers, hair combs and pins, hammers, *hats*, headdresses (see *hat*), healing sticks, helmets, housefronts (see *house*), house posts (see *house*), *jewellery* (such as *bracelets*, earrings, *labrets*, nosepins, rings), ladles (see *spoon*), leg-

gings, *masks*, mats, mortars, necklaces, *paddles*, pestles, *petroglyphs*, pictographs (see *petroglyphs*), pile drivers, *power boards*, puppets, *rattles*, rings (for fingers), soulcatchers, *spindle whorls*, *spirit canoes*, *spirit boards*, spoons, *talking sticks* (speaker's staffs), throwing sticks, *totem poles*, trays, tunics, *weapons* (such as *harpoons*, knives, war clubs), *welcome figures*, and *whistles*.

Decorated objects after contact include: *argillite* works such as pipes, plaques, plates, model poles and model houses; clothing; doors; glass (blown and/or etched) pieces such as vases and plates; jewellery such as brooches; paintings (oil or watercolour); silkscreen prints; sculptures.

Deer

□ Blacktail (or mule) deer is the most common species in the region, and white-tailed deer now also inhabit the southerly portion.

Deer were an important food resource and, in some areas, were the most widely hunted land animal. Hunters sometimes tricked female deer with whistles made to imitate the cry of a fawn. Deer hooves are used as ornamentation, and bunched together, they make an appealing rattling noise. The healing sticks of *shamans* often feature hoof rattles.

Deer is sly and clever in some stories, outwitting enemies with cunning and magic. In Kwakwa̱ka̱'wakw mythology, one of deer's tricks is the "fog box," which foils pursuers by emitting thick fog.

In Nuu-chah-nulth stories, on the other hand, Deer is dull-witted and simple-minded.

In the art, Deer is represented fairly naturalistically, with a long, narrow snout; delicate, regular features; smallish, rounded ears; and antlers.

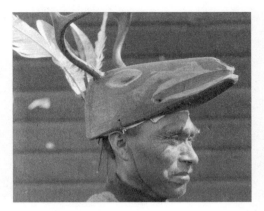

Deer headdress (Nuu-chah-nulth), c. 1935. A. V. POLLARD PHOTO *(DETAIL)*, NAC C-089144

dentalium

(tooth shell)

□ The dentalium (plural dentalia) is a mollusc with a thin, relatively straight and tubular shell that looks like a tooth. The Nuu-chah-nulth and Kwakwa̱ka̱'wakw collected dentalia on the west coast of Vancouver Island; the shells were then traded throughout western North America. Dentalia are popular as ornamentation on clothing, jewellery and *masks*, and were once used as a form of currency. In old photographs, high-ranking women appear clad lavishly in dentalia adornments.

Devilfish

(see Octopus)

Dhuẇláx̱a

(Dla̱'wa̱laxa, Dloowalakha, Dluwalaxa, Dluwulaxa, Klasila, Tła'sala)

□ In the Heiltsuk tradition, the dance ceremony called Dhuẇláx̱a means "Returned from Heaven." In it, initiates play the role of ancestors who journey to the *spirit world* and return with dances bestowed upon them by

their spirit guides. In bygone days, the initiates were removed from the village for *four* days to allow time for this journey, and when they returned they performed their newly acquired dances on four consecutive evenings.

The dancer wears a headdress adorned with ermine pelts. He then disappears and a masked dancer appears, representing his transformation.

dish

(feast dish, feast bowl)

□ Everyday serving and eating dishes were shells or unadorned *wood*, but ceremonial and feast dishes were carved and decorated. A wide variety of animal imagery appears on dishes and bowls, and hosts of *potlatches* compiled large collections of dishware featuring *crests* of both family and *clan*.

Feast dishes are made in many sizes, some up to 4 metres (12 feet) long, and sometimes take the form of a being or object (a canoe, for example, or the entire head and body of *Dzunuk̲wa*), with smaller dishes designed to nest inside the largest (often representing smaller elements of the whole, for example Dzunuk̲wa's large breasts). Common animal motifs used for bowls and dishes include *Seal*, *Halibut* and *Beaver*.

Djilakons

(see Creek Woman)

Dluwulaxa

(see Dhuẁláx̌a)

dog

□ Pre-contact Northwest Coast societies had domesticated dogs. Dogs were used as scent

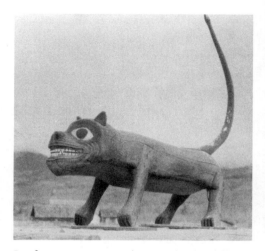

Dog figure at Kitwanga, northern British Columbia, c. 1930. DEPT. OF THE INTERIOR PHOTO, NAC PA-041182

trackers or were sent into bear dens to rouse the animal and send it toward waiting hunters. In some regions, dogs were used as pack animals, fitted with specially constructed saddlebags and carrying up to 23 kilograms (50 pounds). The Coast Salish raised a special breed of dog for its wool, which the women wove into *blankets* and capes. These dogs were white, small and barkless. This breed died out in the nineteenth century, perhaps because of the near-extinction of Salish weaving after the introduction of European textiles.

Dogs are creatures with a special position: they are related to wild animals such as wolves, foxes and coyotes, and yet live in the company of humans. Belonging to two worlds gives them powers, knowledge and significance.

Dogs occasionally appear in the mythology and art, particularly of the shamanic variety. Dog may sometimes work as an agent of *transformation*, a guardian or a spirit helper. The dog is an enemy of the dangerous *Land Otter* and is capable of detecting the true

nature of disguised evil-doers. Both *witches* and *shamans* may use real dogs, as well as dog spirits and talismans, in their work.

The Heiltsuk Cannibal Dance ceremony had its beginnings when a woman gave birth to Supernatural Dog pups, who transformed into men and eventually located the secrets of *Baxwbakwalanuxwsiwe'*, the Cannibal-at-the-North-End-of-the-World, only to be eaten by him in retaliation for this transgression.

In one version of the Haida *Bear Mother* story, a dog who was the companion of Bear Mother's brother aided in the heroic rescue of Bear Mother from her dangerous Bear husband-kidnapper.

Some groups, such as the Heiltsuk and the Haisla, had a ceremony called the Dog-Eating Dance, during which an initiate supposedly ate a live dog as part of the performance.

Certain Kwakwa̱ka'wakw tribes considered *names* for dogs to be an inheritable property.

Dogfish

(Shark; see also Dogfish Woman)

☐ A small bottom-feeding shark, the dogfish is not considered appealing as food. People generally are wary of this fierce, solitary, wandering creature. The Nuu-chah-nulth feared giant, malicious Shark monsters who lived in deep holes under cliffs and liked to eat canoes.

Dogfish is an important *crest* and mythic being among the Haida, and is one of Haida artist Robert Davidson's favourite subjects. Haida artist Bill Reid also created many impressive Dogfish designs.

Depictions of Dogfish feature high, domed heads, that actually represent the snout; sharp, triangular teeth in a large, downturned, mouth; parallel lines representing gills in the cheeks; large, round eyes with elliptical pupils; prominent spines; and large, asymmetrical tail flukes. Dogfish images may also feature a hooked, beakish nose, and a separate pair of circular designs representing nostrils, which on sharks are located on the underside of the head.

Dogfish Woman

☐ Dogfish Woman is an important Haida *crest* and story being. She is a powerful hybrid creature who wears a crown and is a close relative of *Dogfish*. Dogfish Woman was once fully human, but was abducted by Dogfish—some say for teasing him about having two penises—and gradually transformed into a human-shark hybrid creature. Her metamorphosis is sometimes associated with changes in weather. The representation of a *labret* (a lower lip ornament) on an image of Dogfish indicates Dogfish Woman in her marine guise.

Dolphin

(Porpoise)

☐ Species frequenting Northwest Coast waters are the harbour porpoise, the Pacific white-sided dolphin and the Dall's porpoise. They were sometimes hunted.

Among the Tlingit, porpoise was called "poor man's food," because of an unappealing body odour that it apparently causes when consumed by humans.

Dolphins and porpoises are rare in the art but they do occasionally appear. The depiction of Whale features a rounded, continuous head and snout, but Dolphin (or Porpoise) has a more rectangular head and a more pronounced snout, without the presence of

teeth. In contemporary art, Dolphin is often portrayed naturalistically.

down

(see feather)

Dragonfly

☐ Dragonfly occasionally appears in both *crest* and shamanic contexts. Dragonfly is a minor being, but is one of the few insect species represented in the art. Among the Haida, Dragonfly is the only insect that is a family crest.

Young Haida males were told to eat dragonfly wings to increase their speed as swimmers. Dragonfly is a mobile, active, colourful creature which people use to represent dynamism, motion and change.

Dragonfly is identified in the art by a prominent thorax, double wings, a broad face and large eyes. It may have small human-like arms and hands. In some depictions, Dragonfly has a curled proboscis, like *Mosquito*; but unlike Mosquito, Dragonfly is usually toothless and benign in expression. Dragonfly may have a human face on its nose between the eyes, a feature based on the insect's natural appearance.

drum

☐ Drums, along with *rattles*, are a primary percussive instrument, used in both ceremonial and shamanic contexts. Artists often use *paint* to decorate the hide drum on a circular wood frame with two-dimensional designs. The large, hollow, wooden box-drum is frequently used during ceremonies and dance performances. The sides of a box drum are often decorated with painted designs.

Depictions of drums sometimes appear in the art.

duck

☐ At least twenty-six duck varieties are common to the Northwest Coast, but they rarely appear in the art and mythology. Some bird figures on traditional works have been identified as *Mergansers*. Mergansers are fish-eating diving ducks, recognizable by the showy, crested tufts on their heads.

Young Haida boys were taught that eating the tongues of diving ducks would increase their capacity for swimming. The Nuu-chah-nulth have stories of colourful headless Supernatural Duck creatures.

A representation of a duck may symbolize the ability to move in diverse realms, or special fishing skills—or, more precisely, the human desire to access such powers.

duntsik

(see power board)

dwarf

☐ Dwarf-like monsters are common in Northwest Coast mythologies. *Bak̓was*, the Wild Man of the Woods, is, for example, a prominent forest-dwelling dwarf-sized monster who frequently appears in Kwakw̲a̲ka'-wakw art and stories.

Nuu-chah-nulth stories tell of a race of dwarfs who abduct people and take them inside of mountains to dance, using "earthquake feet." Upon meeting one of these creatures, a person might steal some of its power by absconding with a piece of its body or clothing.

Dzunuk̓wa

(Tsonoqua, Wild Woman, Wild Woman of the Woods; see also Dzunuk̲wa of the Sea, Property Woman, Tal)

☐ Dzunuḵwa is the Kwakwaka'wakw name for the region's famous Wild Woman of the Woods. Northern tribes have their own names and stories for a similar, related Wild Woman being. Among the Tlingit, for example, her name translates to *Property Woman*.

Dzunuḵwa is a giant, hairy, bearded, black-bodied, big-breasted, wide-eyed female monster. She is physically strong enough to tear down large trees, spiritually powerful enough to resurrect the dead, and possesses magical treasures and great wealth. She eats human flesh, travels underground, and makes lightning with her supernaturally loud voice. Her echoing cry is "Huuu huuu huuu."

Dzunuḵwa guards and protects her children, who are all the creatures and spirits of the forest. Human children who wander are likely to be captured by her and thrown into the basket on her back, especially if they are stupid enough to eat the food with which she tempts them.

Her two weaknesses are vanity and stupidity, and a clever person who knows these

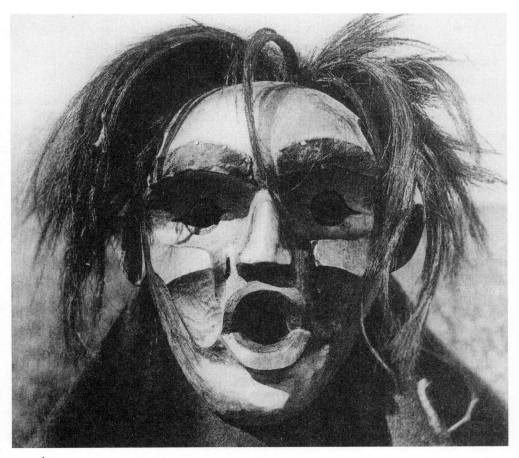

Dzunuḵwa mask (Kwakwaka'wakw). EDWARD S. CURTIS PHOTO, NAC C-033518

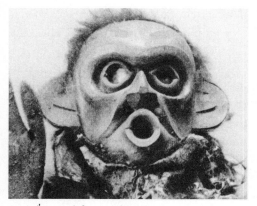

Dzunukwa mask from northern Vancouver Island
(Kwakwaka'wakw). EDWARD S. CURTIS PHOTO,
NAC C-030921

breaking and *potlatch* closing ceremonies. On these occasions, the *mask* is called *Geekumhl*, and may be endowed with a masculine, warrior-like nature.

Dzunukwa may be identified by her upthrust hands; large head; large, round eyes which may appear sleepy; big breasts; thick red lips and open mouth; and thick, long, dark hair, which often includes facial hair. She is often coloured black. The red of her lips results from the human blood that she regularly drinks. The *skulls* of children she has eaten may adorn her. Her beckoning, dangerous, outstretched arms may lead people to mistakenly describe Dzunukwa's image as a *welcome figure*.

weaknesses can trick her, slay her, and steal her treasures.

When Dzunukwa's skull is used as a wash basin, the water gives children anointed with it remarkable strength. She occasionally endows select, fortunate and clever individuals with great wealth.

As a spirit connected with wealth and *Coppers* in particular, Dzunukwa's image may be worn by a Kwakwaka'wakw *chief* at Copper-

Dzunukwa of the Sea

☐ In Kwakwaka'wakw myth, Dzunukwa of the Sea is the *undersea world* equivalent of the forest *Dzunukwa*. She is depicted in the company of sea creatures and may have marine motifs such as fins or scales decorating her face and body.

E

Eagles, print by Jeff Greene (Haida): split Eagle with Whale heads in the wing joints, humanoid face in tail.

Eagle

(see also Eagle Woman, feather, Sea Eagle)

☐ The bald eagle is common all along the coast, while the golden eagle lives mainly in moun-

Eagle Spirit, print by Maynard Johnny Jr. (Coast Salish): Eagle, upside-down Human.

tainous regions. Eagles are large birds of prey with impressive hunting and fishing skills. In the past, some tribes regularly hunted and ate eagles.

Eagle is one of the most important beings in the art and mythology. It is respected for its intelligence and power, as well as its extraordinary vision, in both the literal and figurative senses. In many regions, Eagle *clan* families are traditionally the most prominent, and Eagle *chiefs* the most powerful. Eagles in myth are, likewise, usually noble characters. Eagle spirits are associated with lofty ideals and the pursuit of freedom.

Eagle is revered as a powerful hunter. Groups of mythical Eagles may gather for co-operative whale hunting expeditions, since, unlike the giant *Thunderbird*, Eagle is not strong enough to hunt whales alone. Eagle may often be depicted with *Salmon*, one of its favourite foods.

Eagle *feathers* and down are sacred: traditionally, *shamans* believed in their healing powers and used them in a variety of ceremonial and ritual contexts, such as honouring a respected guest.

In some Haida myths and legends, Eagle and *Raven* are close companions and serve as alter egos to one another. They are two halves of the great whole, often divided and often united. Although they are technically equals, the Trickster Raven is the better known.

Eagle and Raven are the two *clans* among the Haida and Tlingit. Eagle is one of four main *crests* among the Tsimshian, and one of three major Heiltsuk crests.

In the art, Eagle is identified by a powerful beak whose upper half ends in a strong downward curve, which may "recurve," or hook back toward the body. Eagle has no ears, or small ears (which may indicate magic powers and the intention to depict a Supernatural Eagle). Often Eagle is shown with *ovoid* eyes; *split U* feather, wing and tail *feather* motifs; and sharp, curved talons. Eagle spirit helpers and Supernatural Eagles often feature either a prominent "crown" of feathers or two curly protuberances atop the head.

Eagle Woman
□ Eagle Woman is a beautiful, high-ranking legendary human who married *Eagle* and bore two children with him. She was unhappy and missed her family, however, and bravely attempted to escape and return to her own village. Her attempt nearly failed when she came to a deep, wide river, for how was she to swim across it with two small children to carry?

Her resourcefulness saved her, as she had an inspired idea. She tied one child to the end of each braid of her hair, leaving her arms free for swimming. Thus, she and her children survived, and her descendants today can proudly claim images and stories related to Eagle, and Eagle Woman, as their rightful legacy.

Earthquake

☐ The Northwest Coast region is prone to earthquakes. Both the Kwakwa̱ka̱'wakw (in the *Dhuwláx̌a*) and the Nuxalk (in the *Sisaok*) used *masks* of personifications of natural elements such as Earthquake, *Sun, Moon, Echo* and others. The Earthquake mask has humanoid features, and a movable visor that comes down to cover the eyes.

Echo

☐ The word "echo" refers to the fact that hidden singers throw their voices so the sounds seem to be coming from the masked dancer. The Echo *mask* shows the evolution of creatures from sea to land to sky, and features a variety of interchangeable mouthpieces, representing different creatures. The base mask features a wide open mouth.

Elk

(Wapiti)

☐ Elk once inhabited Vancouver Island and regions to the south. They were regularly hunted. Elk occasionally appears in stories but is uncommon in the art. When Elk does appear, it can be identified by its antlers.

Other ungulate species that inhabit either the Northwest Coast or neighbouring regions and that may occasionally appear in the art and mythology include caribou, moose and *mountain sheep*.

eulachon

(candlefish, oolichan)

☐ Eulachon is a species of smelt, a small, oily sardine-like fish that runs in large numbers in early spring and provided both food and fuel. They are eaten both fresh and dried. Their oil, called grease, is a prized commodity.

Eulachon do not breed in Haida Gwaii waters, so they were not a traditional Haida resource. In other areas, they were one of the primary resources. The Tsimshian had a kind of monopoly on the grease trade, which brought them considerable wealth. The prominence of eulachon oil as desirable commodity resulted in local trading routes into the interior of being nicknamed "grease trails."

A wealthy *chief* might ceremoniously throw a quantity of eulachon oil on a fire during a gathering, as a symbolic gesture indicating wealth and status. Such a gesture during the *potlatch* often functions as a direct challenge to rivals to match the host chief's extravagance.

Eulachon appear in stories but rarely in the art.

F

feather

(see also Eagle)

☐ Feathers and down are often used in various ceremonial contexts and are symbolic of supernatural powers such as extraordinary vision or the ability to travel beyond earthly realms. Feathers may also symbolize communication, healing and hospitality. Eagle down was displayed and spread as a welcoming gesture in honour of a respected guest.

In some groups, a feather functions as a speaker's staff or *talking stick*. Feathers among the paraphernalia of a *shaman* indicate a mystical knowledge of flight. Eagle down and swan down are used by the shaman during healing rituals, the down being applied to the shaman's and/or the patient's body.

Today, eagles are protected. In Canada, people may not legally possess eagle feathers, so artists often substitute turkey feathers in contexts that traditionally called for eagle feathers. In the United States, Native people are allowed to possess eagle feathers, with some restrictions.

Abstract feather motifs—often incorporating the *split U* design element—occur frequently in graphic designs. More naturalistic feather renderings are less common, and sometimes indicate an artist's association with inland or eastern cultures.

Fire

☐ Fire is often personified in the art and mythology. Various types of fire feature as *crests* in some societies. In one tradition, The-One-Sitting-on-the-Fire is a male entity, and represents the fire's form, while Heat-Under-the-Fire-Woman, his wife, represents the fire's warmth.

Fireweed

☐ Fireweed is a tall perennial plant of the evening primrose family. It grows along the coast in newly exposed areas, such as those burned by fire, and is gathered for medicinal applications.

Fireweed is one of four main *crests* of the Gitxsan, a Tsimshian people.

flood

☐ Most Northwest Coast cultures have myths and legends relating to a great flood that covered the entire surface of the earth in ages past. Some myths say that the flood was brought about by the misdeeds of *Raven*; others blame a worldwide imbalance caused by selfish human behaviour.

Legends explain that the people survived by rafting canoes together around the only exposed land: the peaks of the highest mountains. Prominent horizontal lines visible in the rock faces of these mountains are reminders of

the terrible cleansing flood. These are the imprints left by the rafted canoes, whose motions chafed the peaks. Coast Salish lore claims that the wide range of their territory is the result of the flood: their once-united ancestors were carried afar in their respective canoes by the flood waters. In one story, they tied their canoes to an *arbutus* tree on the top of a mountain to attach themselves to their homeland.

flounder

☐ The flounder is a flat, wide, bottom fish that has an appealing, amusing representation in the art. Flounders are generally depicted with googly, very close-set, sometimes asymmetrical eyes; a wide, flat, round body; small fins; and a benign expression. Flounder images are particularly well suited to the decoration of food bowls and platters.

Flying Frog

(see also Frog)

☐ Flying Frog is a fusion of bird and amphibian. It has the head and face of *Frog* combined with feather and wing motifs. Flying Frog is a Tsimshian family *crest*.

Fog Woman

☐ Fog Woman is also known as Salmon Woman. In some stories, she is a high–status being who created *Salmon*, a gift that *Raven* did not properly appreciate, but for which humankind is eternally grateful. In other stories, Fog Woman is Raven's wife, or one of his wives (Raven is an infamous womanizer).

four

☐ The number four is considered sacred, powerful and auspicious in many Northwest Coast cultures. Indigenous societies all over North America tend to hold the number four (and twice four, or eight) in high regard. The *masks* of some beings appear in multiples of four, and traditional ceremonies often span four or eight days. Among the Nuxalk, some ceremonies are scheduled to begin on the fourth day after a full moon, and Tlingit *shamans* own a set of eight separate masks. Artworks often display quadrilateral balance, and motifs appear in multiples of four.

Two Loons, print by Richard Hunt (Kwakwaka̱'wakw): split Loon in quadrilateral symmetry.

Frog

(see also Crab, Flying Frog, Frog Woman, Sea Frog)

☐ Many species of frogs—and toads—live on the coast. The "frogs" on Haida Gwaii (Queen Charlotte Islands) are actually northern toads. One Haida name for the frog means "Crab of the Woods."

Frog is a creature of great importance in Northwest Coast art and culture. As a creature that lives in two worlds, water and land, the

frog is revered for its adaptability, knowledge and power to traverse worlds and inhabit diverse realms, both natural and supernatural. Frogs are primary spirit helpers of *shamans*.

Frog is a great communicator, and often represents the common ground or voice of the people. These are vocal, singing creatures, and the voice and song are believed to contain divine power and magic. In the art, Frog is often shown sharing its *tongue* or touching tongues with another creature in an exchange of knowledge and power.

Many stories and artworks refer to the cruel and remorseless killing of a frog at the hands of boys. In revenge, *Volcano Woman*, the protector of the forest, destroys their home village because the people do not share her outrage nor do they attempt to restore balance through sacrifice and supplication.

In Haida mythology, one of the wives of *Raven* is *Creek Woman*, who lives in stream headwaters and whose familiar is Frog. Other Haida stories feature Frog as Raven's wife, child or alter ego.

Witches also favour Frog and its powers, in some instances using the slime from its skin to create poisonous concoctions. A representation of a shaman with a Frog may, likewise, feature a posture suggesting extraction of poison from Frog's skin.

Frog is often associated with *copper* and great wealth. Legendary Haida princes are said to have attended feasts wearing necklace chains made of living frogs, while their wives adorned themselves with living rufous *hummingbirds*, tied to their hair.

Frog designs are commonly used as decora-tive elements, so that Frog faces, for example, peek out from another creature's ears, mouth or hands. In symbolic terms, the emergence of Frog from these orifices may represent an eruption of aspects of unseen interior and other worlds.

Frog is identified by its flat nose; broad, toothless mouth; large, round, often lidless eyes; short body; bent legs; no tail; no ears or small circles or holes for ears; protruding tongue, and elongated or webbed toes.

Frog Woman
☐ Frog Woman is an ancestral being. She is depicted as a human but with strong *Frog* associations as a reminder of her important myth-time role as the founder of Frog lineages.

frontlet
☐ The frontlet is a small *mask* worn over the forehead, attached to a headpiece that is some-times made of a piece of cedar bark mat but is often a framework made of baleen splints. It displays the *crests* of a *chief* or high-ranking person and is adorned with materials such as *abalone shell*, *operculum*, *copper*, sea lion whiskers and ermine pelts to signify wealth and power.

At a ceremony, the top of the headdress may hold eagle or other *down*, which floats away as the wearer dances, and is a symbol of fortune and honour.

fruit
☐ Wild fruit, depictions of which sporadically appear in the art as decoration, include wild apple, bearberry, blackberry, blueberry, cherry, cranberry, huckleberry and salmonberry.

G

Gagiid

(Gageet, Kushdaka, Kushtaka)

☐ In Haida and Tlingit legend, a Gagiid (Haida) or Kushdaka (Tlingit) is the transformed state of the soul of a dead, usually drowned, human. Drowning is considered the worst form of *death*, because the body is often lost, and without proper ritual treatment, the soul is doomed to wander the earth discontentedly.

A Gagiid is a powerful hybrid being, equally at home in water and on land. It has great powers of illusion and disguise. Children are taught to avoid being lured or fooled by this creature. Dangerous and often malicious, it likes to steal children and other vulnerable souls, to scare women, and to cause natural disasters such as storms and famines.

Gagiid representations often have a sharply upturned but unfriendly mouth, with or without teeth, and may exhibit a combination of human and otter features and motifs. They often have spikes around the mouth to indicate the bones and spines of their prey.

Gakhula

(Intruders)

☐ The Gakhula are Kwakwaka'wakw masked figures who theatrically interrupt the *Dhuw-láx̌a* ceremony and are forcibly removed. Gakhula *masks* are varied. They are often crudely made and have human features with many different expressions.

Geekumhl

(Gi-kumlth)

☐ Geekumhl (meaning "chief mask) is the name for the *mask* representing the Kwakwaka'wakw male *warrior* form of *Dzunuḵwa*, who inhabits mountains and high-altitude forests. A *chief* wears the Geekumhl mask as a warning not to oppose his family in ceremonies concerning warrior spirits and the breaking of Coppers. The male warrior form of *Dzunuḵwa* is hairy, huge, powerful, and wide-eyed, and is said to be considerably more alert than she is.

ghost

☐ Ghosts are the souls of the dead, and they have their own villages and social organizations in the *spirit world.* In some Northwest Coast cosmologies, their seasons and daylight hours are exactly opposite to those in the human world. *Shamans* undertake dangerous voyages to ghost towns in the spirit world to gather knowledge and to retrieve lost or endangered souls.

In Kwakwaka'wakw mythology, ghosts frequently accompany *Bak'was*, the Wild Man of the Woods, who is especially associated with the ghosts of the drowned.

Ghost dancers appear in the ritual of *Winalagalis* (War Spirit) in Kwakwaka'wakw ceremonies.

In Nuxalk cosmology, the spirit world is populated by ghosts and everything is exactly opposite to the world of the living. The scarcity of food there drives ghosts to visit the *mortal world*. These unwelcome visitors may be recognized by their singing and whistling.

In the art, ghosts are often identified by *skull* masks and ornaments, or by faces, especially eyes which look hollow and bodies which appear emaciated.

Gilakons

(see Creek Woman)

Gitakhanees

(Gitakanis)

☐ Gitakhanees are Kwakwaka'wakw dancer-performers representing a group of Tlingit slaves and their chief in the *Dhuulláxa* ceremony. Slaves were once common in the region and were the lowest-ranking class of people in traditional Northwest Coast societies. The *masks* have human faces, and the main distinguishing feature is a plume of feathers extending from the forehead.

Gonakadet

☐ Gonakadet is a Tlingit sea monster who bestows wealth on lucky individuals. Many sea monsters have associations with extravagant riches, undoubtedly because of the actual bounty which Northwest Coast peoples regularly extract from the sea.

Gonakadet resides in Tsimshian territory, under a cliff at the mouth of the Nass River. An early Tlingit *chief* won many privileges when he refused to retaliate violently after Gonakadet swallowed two of his nephews. Instead, the chief invited the monster to a great feast, impressing him with diplomacy and hospitality. Gonakadet returned the nephews unharmed and bestowed beautiful gifts, as well as rights to *crests* and songs, on the fortunate family.

Goose

(and **Swan**)

☐ Species that inhabit the area include the black brant, Canada goose, snow goose, white-fronted goose, whistling swan and trumpeter swan. Some species were hunted and eaten.

Goose and Swan are sometimes associated with *witches*, and are thought to have the special powers of creatures that have access to multiple realms.

Goose occasionally appears as a family *crest*, for example among the far northern Eyak peoples, who eventually became a part of Tlingit society. However, both Goose and Swan are relatively uncommon in the art.

Great Dancer

(see Wihalait)

Grebe

(Diver)

☐ Five species of grebes inhabit the Northwest Coast, most of them winter visitors. Grebe is a diving bird whose ability to

travel underwater suggests associations with *shamans*, who are believed to share this talent. Grebe is a rare creature in Northwest Coast art.

Grizzly-Bear-of-the-Door

☐ In Kwakwa̱ka'wakw mythology, Grizzly-Bear-of-the-Door is one of the guards and the gatekeeper of the dwelling of *Baxwbak-walanuxwsiwe'*, the Cannibal-at-the-North-End-of-the-World. Grizzly-Bear-of-the-Door is also one of the mythic beings in the *Hamat́sa* (or Cannibal Dance) ceremony.

Groundhog

(Marmot)

☐ Groundhog is a *crest* of some Tlingit *clans*, and appears as a being in myth. Groundhog may actually be more accurately identified as Marmot: marmots are mountain-dwelling relations of groundhogs, and the Tlingit people trace their ancestral roots to mountainous inland terrain.

Marmot depictions feature large beaver-like front teeth, and a rounded, mammalian head, a short nose and small ears.

Grouse

☐ The Northwest Coast is home to a variety of grouse, ptarmigan and quail species. Many Nuu-chah-nulth *rattles* depict Grouse, but otherwise they are not very common in the art and mythology.

Grouse, noted for its alertness and caution, may be depicted in a posture of alarmed, upward flight. Small, round feather motifs help to identify Grouse. Grouse is one of the forty forest beings in the *Atła̱kim* (Dance of the Forest Spirits) of the Kwakwa̱ka'wakw.

Guardian Spirit Power Dance

☐ Guardian spirits are a feature of all Northwest cultures, especially important among the Coast Salish, whose primary ceremonies involve expressions of an individual's relationship with his or her guardian spirits. A guardian spirit is generally obtained during a vision quest, a ritual involving purification rites and physical isolation from other humans. A person may acquire a guardian spirit entity of almost any form, although a few, such as a two-headed serpent, an elk-like giant, or a mountain-dwelling lizard-like being are accessible only to *shamans*. The guardian spirit bestows knowledge, power, songs and dances, and the individual displays these gifts through performances and/or sacred ritual practices.

Gull

(Sea Gull)

☐ Of the many species of gull in the region, only the glaucus-winged breeds along the coast. Gull eggs were one of the many foods which women and children gathered in the spring.

The gull is a common variety of shorebird whose status as a creature at home in two realms leads to occasional appearances in shamanic art. Gull also appears in association with other sea beings, such as K̲umugwe', chief of the *undersea world*, who may wear Sea Gull as a headdress. Sea Gull occasionally appears as a *crest*, among certain far northern tribes.

In artistic renditions, Sea Gull has a straight, medium-length beak and neck, and wings that are often white. It is not a common motif.

H

Halibut

☐ Halibut was an important food resource for Northwest Coast societies, rivalling salmon in some regions. These fish were, and are, particularly important to the Haida, who had less access to salmon and eulachon than many mainland coastal groups.

Halibut is a deep-water ocean fish whose image frequently appears in the art, and its representation in two-dimensional and shallow relief carving is often appealing and amusing, like that of Flounder. Halibut images make logical choices for food bowls and platters. Halibut images occur in both shamanic and *crest* art.

The Nimpkish tribe of the Kwakwa̲-ka̲'wakw trace their origins to a halibut-like being, who came ashore after the great flood, transformed from fish to human, and began constructing a house. *Thunderbird* heard the being's plea for help to raise the heavy beams and came to his aid. Thunderbird likewise assumed human form and, with the halibut-like being, became a founding ancestor of the Nimpkish peoples, who forevermore may claim the right to these *crests* and stories.

Old-style halibut fish hooks are fashioned from either two lashed pieces of wood or a single fork of a tree branch, and are usually decorated or sculpted with images that are intended to lure the fish and endow the hook with spirit power. Before metals became widely available, the barbs were often made of bone. A well-made traditional halibut hook can bring in a fish weighing over 23 kilograms (50 pounds). The hooks were often baited with octopus. *Raven* likes to steal bait from halibut hooks, and since the beginning of time halibut fishers have been frustrated by his antics.

Halibut is identified by a wide, flat, rounded body; two large, closely set eyes; a downturned mouth; continuous fins on both sides of the body; and a broad tail. The Supernatural Halibut *mask* has curly horns that indicate supernatural qualities.

Hama̓tsa

(Cannibal Dance, Tanis, Wildman)

☐ The word "Hama̓tsa" refers both to an elaborate dance ceremony and the initiates who perform it. The Hama̓tsa dance is an important part of the rituals that take place during the Winter Ceremony of the Kwakwa̲ka̲'wakw.

Among the Heiltsuk and Oweekeno, the Hama̓tsa ceremonies are called the Tanis dance series. The Kwakwa̲ka̲'wakw developed the most complex and elaborate Hama̓tsa rituals, after originally obtaining the Cannibal Dance ceremony from the neighbouring Heiltsuk and Oweekeno, through war and marriage.

A Hamaṫsa c. 1920 at Quatsino, northern Vancouver Island (Kwakwa̲ka̲'wakw). B. W. LEESON PHOTO *(DETAIL)*, NAC PA-068271

The Hamatsa novice undergoes intense initiation rituals and ceremonies, which take place in the winter, the season when supernatural beings make annual contact with the world of humankind.

Hamatsa performances are complex and powerful, involving many objects, motifs and beings, particularly *Baxwbakwalanuxwsiwe'*, the Cannibal-at-the-North-End-of-the-World, and the members of his household. Aside from the initiate and his two female attendants, *Kinqalalala* and *Qominaga*, the main participants include *Grizzly-Bear-of-the-Door*, *Nuḻamaḻ*, and three giant cannibal bird attendants (*Cannibal Raven*, *Crooked-Beak* and *Huxwhukw*).

The ceremony generally features *four* components: abduction, during which the initiate acquires a ravenous hunger for human flesh; capture and return to his community; symbolic taming and purification; and the display of new powers. Through this process, the initiate is transformed. He has learned to control his cannibalistic impulses and emerges triumphant over the monster within. Thus, the Hamatsa rituals and performances express the importance of self-control and socialization. Hamatsa *masks* are large and spectacular, and skull imagery is pervasive on regalia and props.

hand

(Hand of Friendship, Hand of Creation)

☐ With palm open and facing upward, the hand indicates friendship, hospitality, peace and good will. In some contexts, the same hand may also represent powers of creation.

Among the Nuu-chah-nulth, the sight of a right hand protruding from the ground holding a *rattle* is a propitious sign, while the sight of a left hand is a bad omen, foretelling death.

A hand motif often features an elongated and enlarged thumb, and the palm may contain images of joints. These hand designs were, historically, found in the presence of other body parts, as part of a larger design. Today, the hand alone has become a popular motif.

harpoon

☐ Traditional whaling, fishing and hunting implements include harpoons, fashioned from wood, bark and sinew, with tips of shell, horn, bone or stone. Artists sometimes include harpoon imagery in their creations, often as a way to pay homage to traditional hunting methods. Harpoon motifs are particularly popular with Nuu-chah-nulth artists, because whaling was a prestigious activity among their ancestors.

hat

☐ Many kinds of hats in a variety of materials—woven headbands and conical hats, carved *wood* helmets and *frontlets*, animal skin headdresses—have a range of functions (sacred, shamanic, practical, ornamental, protective). Hats may indicate status and feature *crests* to display *clan* associations.

The cylindrical tower atop a northern woven hat is segmented, with each segment (called a *skil*) recording an instance of ceremonial public validation of the hat and its current owner.

A Nuu-chah-nulth whaling *chief*'s basketry hat is woven in a conical shape, topped with a bulbous dome and decorated with whaling motifs.

Tlingit "Bear's Ear" headgear, whether real

or representational, lends great strength and courage to the wearer, and is therefore worn during war, or placed on the head of a dying man.

One legendary Haida magic hat contains an ocean and a wealth of flora and fauna, and allows the wearer to raise tidal waves with a wrinkle of the brow.

Hawk

☐ At least ten hawk and falcon species live in the region, although they are not nearly as prominent in the art as *Eagle*. Their feathers are used to make ceremonial and decorative objects. Hawk is often associated with *Sun*, and is revered for its superior vision and skill in hunting.

Hawk is a minor *crest* among some Kwakw̱a̱ka'wakw tribes and a helping spirit in shamanic contexts.

Hawk depictions are similar to Eagle, but the beak is generally shorter, and usually is even more dramatically hooked towards the mouth—or "recurved." A Hawk depiction may have teeth.

Hawk Man and Hawk Woman are transformation beings depicted with largely human features, aside from their recurved, beak-like noses.

Heron

☐ The great blue heron is a year-round inhabitant of the region. Traditionally, it was valued both as a winter food and as an alarm-raiser: a heron cries out a loud warning at the approach of humans.

Heron frequently adorns the tops of Kwakw̱a̱ka'wakw *masks*, and among the Haida is a *crest* for some members of the Eagle

clan. In myths, Heron may appear as a watchman for Killer Whale communities.

Often mistaken for *Crane* in the art, Heron features a very long neck, often arched; very long, thin legs; and a very long, pointed bill. Heron depictions frequently have blue, blue-grey or green-grey colouring.

herring

☐ The herring is a small fish that was an important traditional food resource. Herring flesh and oil were useful, and the dried roe was a delicacy and a popular trade item along the coast. Native people placed hemlock boughs or kelp leaves in shallow water for herring to lay their eggs on, so that they could easily collect the roe.

In Nuu-chah-nulth mythology, the Herring People share a house in the *undersea world* with the Salmon People. Both com-munities are benevolent toward humans, unless irritated by ritual neglect or disrespect. Herring is not a common motif in the art.

Hokhokw

(see Huxwhukw)

house

☐ The traditional Northwest Coast house was a large rectangular building made with posts, beams and planks of red cedar. In times past, communities inhabited permanent winter villages, but during the busy food-gathering months of summer, often relocated to resource-rich areas. The houses were built so that the planks of walls and roofs could be removed and taken to the summer site.

Housefronts were sometimes decorated with designs in relief carving or applied

Painted housefront of Chief Gold's home, Skidegate, Haida Gwaii, c. 1912. DEPT. OF MINES AND TECHNICAL SURVEYS PHOTO *(DETAIL)*, NAC PA-060840

colour, and the family's stature might be stated with one or more sculpted poles. *Totem poles* could display lineages, *crests*, and family myths. Poles on either side of the central pole might be mortuary or memorial poles, serving to keep alive stories of ancestry. The house posts that held up the beams were often carved with crests.

Doors were very small to keep out inclement weather and also to ensure that visitors, in order to enter, had to bend over—a posture which rendered vulnerable any unwelcome callers. Floors were usually dirt. Cedar mats might provide sitting or sleeping areas.

A house could shelter a number of related families. Cedar bark woven mats, often painted with *clan* crests, functioned as dividing curtains to afford some degree of privacy.

Larger houses could accommodate many guests and had rectangular stages and/or sunken areas where dances were performed.

A house *chief* wielded authority over all the individuals residing under his roof. The highest ranking, wealthiest house chief was generally also the village chief.

House sites and house *names* were both valuable properties. The completion of a new house required the hosting of a *potlatch*, at which the new owner asked for public recognition of his increased status.

There are many models of traditional houses but representations of them in the art are relatively rare. The presence of a house image in a work may suggest the importance of community and ceremony, or the strength, pride and wealth of specific individuals and lineages.

human

☐ Many human heroes of legend and myth are depicted in the art. Strong Man, also known as Dirty Skin, lifts a sea lion and tears it apart to demonstrate his great strength. Gunaxnasimgyet undertakes dangerous journeys to the other worlds above and below the earthly domain. Such legendary heroes are often depicted in transit, riding on the back of an animal spirit guide. Many legends are now lost, which means that the iconography of many older works of art remains mysterious.

Ancestors are very important in Northwest Coast cultures; a human portrait often represents an ancestor figure, who is no less real for being mythical.

Free-standing human figures are often guardians. These protective talismans range in size from amulets a few inches tall to poles several feet high, which may be *welcome figures*. Human-like figures may be personifications of environmental phenomena such as the *sun*, aspects of *weather* such as the wind, geography such as a local *mountain* or other landmark. A non-human being such as a water spirit may appear as a fully humanoid figure, but with the addition of a dorsal fin to indicate a nature that is other than human.

Human-like dolls and puppets were often more than simple toys, some of them having ritual functions. Important events in the human life cycle may be represented by *masks*, regalia and associated dances. The *Atłak̲im* (Dance of the Forest Spirits) of the Kwakwa̲ka̲'wakw, for example, sometimes features Woman Giving Birth, her Child, Husband and Midwife.

The human face traditionally appears in shamanic, *crest*, story and decorative art. Human features commonly mingle with those of other creatures, a formal convention that may represent birthright, kinship, supernatural status, and/or spirit alliances.

A head intended to represent a human often features ears at the sides of the head, while animal entities generally have ears at the top of the head. Two sets of ears may indicate a creature with a dual nature.

Pursed lips often represent singing. Such mouth positions may also suggest talking, wind, shamanic curing techniques that involved sucking and blowing, or whistling (a form of communication sometimes used to summon spirits and popular among *ghosts*). *Tongues* may symbolize *transformation*, shared knowledge and power, and the ability to speak with creatures of different species.

The pupils of eyes rolled back, half-closed eyelids, or empty or closed eye sockets may also indicate a state of trance, shamanic associations or *death* throes. Dying figures are further indicated by marks representing wounds and blood.

Hair was believed to be a source of power. Hair hanging very long and loose may indicate shamanic status (*shamans* did not cut their hair).

Face painting on portrait masks may be symmetrical or asymmetrical, abstract or representational, and often refers to *clan* crests and insignia worn by people during ceremonial occasions. In Nuu-chah-nulth portraits, an ochre-coloured band across the eyes signifies high rank, while a black band signifies lesser rank.

Smaller animal figures carved in relief on cheeks and foreheads indicate that the work has shamanic associations. These figures (which may represent *Mouse, Wolf, Bear, Frog, Land Otter*, etc.) are spirit helpers. They sig-

nify the shaman's gifts and skills, which include unique powers of transformation and exclusive access to sacred knowledge.

Old age is commonly depicted through wrinkled visages, emaciation, grey hair and gnarled limbs. An elderly being may symbolize wisdom and a proximity to death that suggests powers of transformation. An emaciated human image may also represent a ghost, a shaman, or a person being symbolically *ridiculed* (for instance, one too shamefully impoverished to eat well).

Mourning masks may show marked lines on the face, which refer to self-inflicted wounds created as part of the grieving process. *Warrior* portraits may also display such wounds.

Winking figures do not necessarily signify sly understanding, which is today's conventional understanding of this motif, but the artist's intent to express a vital, life-like quality and a supernatural association. Master Carpenter, for example, is a legendary supernatural builder whose carvings, according to the Haida, are so real they seem to wink at the viewer.

White men and women are sometimes represented, recognizable by their colour; they often have relatively small facial features. White men often have copious amounts of facial hair. White women, amusingly, often appear pinched and prim in traditional pieces. In *argillite* carvings, which frequently depict white men, they have sharp, exaggerated noses, wavy hair and, of course, European clothing and shoes.

Hummingbird

☐ The rufous hummingbird is the most common species in the region, and in some areas these tiny, active, well-loved birds are year-round inhabitants.

Hummingbirds nest in the unruly hair of *Dzunuk̓wa*, the Wild Woman of the Woods, and fly around her as she walks through the forest. She is the guardian of the forest creatures, and the protector of Hummingbird.

Haida stories tell of high-ranking women arriving at feasts with live hummingbirds tied to their hair to announce their beauty, wealth, prestige and close communion with the spirit of the bird. Legend has it that this tiny bird is a rainbow, or an animate prism, busily turning sunlight into weightless jewels.

Among Haida people of the Eagle *clan*, Hummingbird is a family *crest*, but it is not traditionally a major motif in the art. Its popularity today indicates that it has become a very important symbol of love and beauty.

Hummingbird is identified by a long, narrow beak (longer, pointier, and thinner at the base than that of *Raven*); prominent eyes; a small head, sometimes with a small curly plume; short wings; and the presence of flowers.

Huxwhukw
(Hokhokw, Hoxhogwaxtewae, Hoxhok-of-the-Sky)

☐ Huxwhukw is one of three Kwakwaka̱'-wakw giant cannibal birds that are the attendants of *Baxwbakwalanuxwsiwe'*, the Cannibal-at-the-North-End-of-the-World, and a part of the *Hamat̓sa* (Cannibal Dance) ceremony. The other two are *Crooked-Beak* and *Cannibal Raven*.

Huxwhukw is a fearsome monster who uses his long bill to crack open human skulls and eat the brains. It is identified by a very

Mask of Huxwhukw, one of the three giant mythical *Hamaťsa* birds. EDWARD S. CURTIS PHOTO *(DETAIL)*, NAC C-020861

long, fairly narrow bill (longer and narrower, typically, than that of *Raven*), which is square-tipped. Often it also features flared nostrils, and black, white and red colouring. Some-times *skull* imagery accompanies this bird. The *masks* can be very large, and sometimes artists combine two or three cannibal bird heads in a single mask.

I

Iakim

(Yagem)

□ A Iakim is a fearsome Kwakwaka'wakw water-dwelling monster who obstructs rivers and causes turmoil in lakes and seas. He is known to capsize and swallow canoes. His image varies from interpretation to interpretation, because his name functions as a general label for sea monsters. Iakim is usually depicted as a creature with a malevolent expression, a large mouth with teeth, and marine motifs.

island

□ Islands are abundant along the Northwest Coast, and they a favourite theme in the contemporary art of the region. In the art and mythology, an island, like any aspect of the environment, is perceived as a living being, with a face, a personality and a spirit.

The Haida people call their archipelago homeland Haida Gwaii, meaning "Islands of the People (or Humans)" or "Islands on the Boundary between Worlds."

J

jewellery

(see also tattoos)

☐ Both sexes wore jewellery and ornaments, which varied regionally. Some such items include earrings, *labrets* (lower lip ornaments), nose ornaments, finger rings, *bracelets*, anklets, neckrings, necklaces, pendants, belts. A bone nosepin ornament may, in some regions, indicate a representation of a *shaman*. A figure with a labret signifies a high-ranking woman.

K

Keeper of Drowned Souls
(see B<u>a</u>k̕w<u>a</u>s)

Khenkho
□ Khenkho is a Kwakw<u>a</u>k<u>a</u>'wakw Super-natural Crane, one of the guards of <u>K</u>umugwe' (Rich One), chief of the *undersea world*. He is recognizable by his long, narrow beak and flared nostrils. Khenkho resembles both *Huxwhukw* and *Cannibal Raven*.

Killer Whale
(Orca; see also Blackfish, whales and whaling)
□ The Northwest Coast is home to many species of whales, of which the distinctive black-and-white killer whale (or orca) is the most common.

The first whales came into being when they were carved in wood by a human, or by *Raven*, or by a Master Carpenter, and then magically infused with a life force.

Killer Whale is a very important *crest* and mythic being among many groups, and one of the most commonly depicted in the art. Killer Whales, widely recognized as *clan* ancestors, are found in shamanic, story and *crest* art. In stories, these majestic creatures are associated with strength, dignity, prosperity

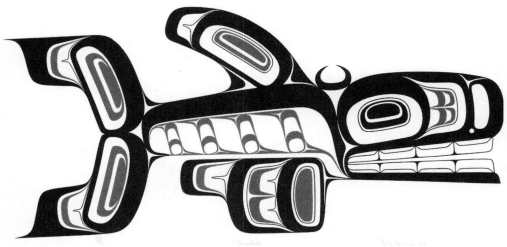

Killer Whale, print by Jeff Greene (Haida).

and longevity. They are also associated with *copper* and wealth.

Killer Whale clans are thought to inhabit villages deep under the ocean. When they are at home, the Killer Whale People take off their black-and-white skins and live like giant humans.

Killer Whales are thought to be the *reincarnations* of great *chiefs*: when a great chief dies, a Killer Whale customarily comes close to shore to take the chief's spirit.

Killer Whales are known to capsize canoes and carry the occupants (and sometimes canoes) into the depths to their villages. On the other hand, Killer Whale often guides people to safety when they are caught on the water in stormy weather.

People consider Killer Whale to be closely related to humans, and also to *Wolf*. Wolf and Killer Whale are both admired for their hunting skill, strength, intelligence and devotion. Killer Whale is sometimes called Wolf of the Sea. According to some myths, the first Killer Whale was a supernatural, white-furred Wolf who entered the sea and transformed. Alternately, a Killer Whale may beach itself and take on the appearance of Wolf in order to wander the earth. These two beings are physical manifestations of one spirit being or essence.

The dangerous practice of hunting whales, the grey whale in particular, was carried out by the Nuu-chah-nulth and Makah. Killer Whales and Wolves are both revered as great hunters, and therefore feature prominently in Nuu-chah-nulth art, religion and mythology. Wolves are credited with giving important whaling secrets to humans. As elsewhere on the coast, people considered Wolves and Whales to be essentially connected—two

expressions of one magical, impressive being, with the power to manifest either form of its nature. The Nuu-chah-nulth apparently did not hunt Killer Whales.

Killer Whale is an important participant in the *Dhuwláx̌a* dance of the Kwakwa̱ka̱'wakw. The Killer Whale *masks* are so large that they sometimes cover the dancer's entire body, and often feature movable fins and tails for dramatic effect.

Haida members of the Raven clan have Killer Whale as a crest. The double-finned Killer Whale is a famous Haida crest, and a figure which artists often depict. The presence of multiple dorsal fins is a sure sign of a divine entity, and Supernatural Killer Whales may have two, three or five. Five-finned Killer Whale is a Haida crest of the Eagle clan. The Haida also have a story about Raven-finned Killer Whale, a whale chief whose dorsal fin is in the shape of the head and beak of Raven.

Killer Whale is a main crest of four clans (depicted differently by each) among the Tsimshian. Among the Heiltsuk, Killer Whale is one of four clans.

All along the coast, fishers and hunters often applied Killer Whale designs to their *canoes* and other paraphernalia. Killer Whale depictions may include a human figure, clinging to the dorsal fin as the whale moves through the water. A number of different myths from various regions may be alluded to with such an image. Often, Killer Whale is shown grasped in *Thunderbird*'s talons. Less commonly, *Eagle* is the captor.

Killer Whale may be identified by a large, long, snub-nosed head; elongated nostrils; a wide, toothy mouth; a blowhole; a prominent dorsal fin; two small pectoral fins; and a

fluked tail. The body is often rounded and smooth. Whales in breaching postures are popular depictions. Additional faces are sometimes embedded in the blowhole, and the dorsal fins may also contain another creature's image.

On poles or house posts, Killer Whale is carved along the length, with its head above or below its body. Sometimes, instead of a full portrayal, Killer Whale is represented by an upright dorsal fin and a blowhole, along with a tail and side flippers, or even by a circle alone, indicating the blowhole.

Kingfisher

☐ The kingfisher is a straight-billed, colourful, crested shorebird. People admire the bird's fishing skills; it is patient, agile and quick. As a creature at home in various environments, the solitary and resourceful kingfisher is also useful as a spirit guide.

Kingfisher (in the form of a puppet) makes a brief appearance in the *Hamatsa* (Cannibal Dance) ceremony of the Kwakwaka'wakw. Kingfisher may often appear in the form of a *rattle*, and Kingfisher images appear frequently as secondary details on intricately carved *Raven* rattles.

Kingfisher depictions often feature a strong straight beak that is less fine and shorter than that of *Crane* or *Oystercatcher*, and a short, strong tail. Kingfisher is commonly depicted with its favourite meal—a fish—in its powerful beak or talons.

Kinqalalala
(Heyleegistey, Kinkalatlala)

☐ Kinqalalala is the female slave of *Baxwbakwalanuxwsiwe'*, the Cannibal-at-the-North-

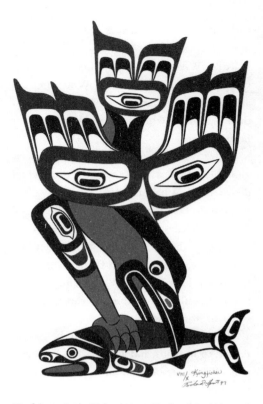

Kingfisher, print by Richard Hunt (Kwakwaka'wakw): Kingfisher holding Salmon in its beak and claws.

End-of-the-World, and the *Hamatsa* (Cannibal Dance) initiate's guide, a role that is generally played by a female relative. Acting as a link between the supernatural and natural realms in the elaborate Hamatsa ceremony, she dances to placate the cannibalistic initiate.

Klasila
(see Dhuẃláẍa)

Komokwa
(see Ḳumugwe')

Komunokas
(see Copper Woman)

64

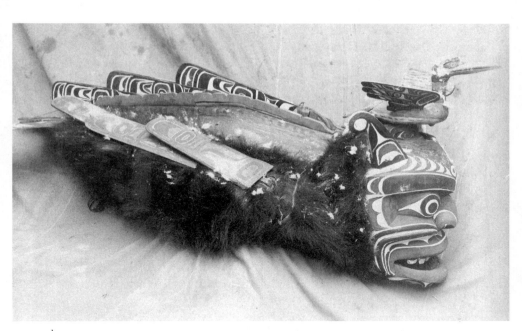

Mask of K̲umugwe' topped by a *Loon*, with a humanoid head nestled between. EDWARD S. CURTIS PHOTO, NAC PA-120426

K̲ulus

(Kolus, Q'olus, Quolus)

□ K̲ulus is the younger brother of *Thunderbird*, whom he resembles. He is very strong, like his big brother. However, K̲ulus is smaller than Thunderbird, and although supernatural, does not have supernatural curly appendages on his head.

K̲ulus has bright white, downy feathers. He is often shown with wings outstretched, like his brother's, to emphasize his strength and power. He is also called Walas (Big), and gave many sky spirit songs and dances to the Kwakwa̲ka'wakw people.

K̓umugwe'

(Komokwa, Komokoa, Qumugwe, Rich One)

□ K̲umugwe' (a Kwakwa̲ka'wakw name that means "Rich One") is the chief of the *undersea world*. Another of his names is Tlakwagila (meaning "Copper Maker"), in reference to his wealth. He is an important *crest*.

The undersea house of K̲umugwe' has live *Sea Lions* as house posts, is full of treasures, and is guarded by sea monsters and a *Supernatural Crane*. Some say the entire house is made of *copper*. He lives there with his powerful wife, *Talio* or Tlakwakilayokwa (Copper Maker Woman) and a host of marine-life servants.

K̲umugwe' is associated with high, rising tides and whirlpools, and many sea creatures such as *Sculpin, Octopus, Killer Whale* and *Loon*. Some say he is a giant octopus.

In the art, the face of K̲umugwe' is large, rounded and heavy, with wide, thick lips; a short, broad nose with flared, elongated nostrils; and wide, round eyes. He may have gill slits, fish scales, green and black coloration, large curled ears or horns, and fish fin and tail designs. And, of course, he is often decorated

with copper. Sometimes the *mask* has round protuberances that may be octopus tentacle suckers, air bubbles or *sea anemones*.

In Haida cosmology, the chief of the undersea world is called *Taangghwaylaana*, the One in the Sea.

Kushdaka
(Kushtaka, see Land Otter)

Kusiut
□ The Kusiut is a prestigious and powerful dance of the Nuxalk that dominates their *Winter Ceremony*. In it, supernatural beings initiate novices by means of tricks and violence. Historical accounts indicate that Kusiut participants have strong connections with the supernatural realm and shamanism. The complex Kusiut songs and dances were carefully practised during the summer months, and include those called Cannibal, Scratcher, Breaker and Fungus.

Kusiut *masks* were carved from red alder and were sometimes burned after use. They depict a variety of spirits, among whom *Thunder* is the most powerful. Innovation, rather than duplication, was encouraged in the creation of new masks. Some of the Kusiut's cannibal elements are related to the *Hamatsa* (Cannibal Dance) ceremony of the Kwakwa̱-ka̱'wakw, who are the southern neighbours of the Nuxalk.

L

labret

□ A labret is an ornament worn in the lower lip. In two-dimensional artworks, a labret may be symbolized by a circle beneath the bottom lip. A labret motif on a non-human representation indicates that the entity has a female nature. Among many tribes, girls underwent lip-piercing (among other rituals, such as seclusion) at the onset of menstruation, and the appearance of the ornament indicated eligibility for marriage. The larger the size of the labret, the higher the woman's rank. Archaeological evidence suggests that in some regions males once wore labrets.

ladle

(see spoon)

Land Otter

(Kushdaka, Kushtaka; see also Otter)

□ Land Otter is the Tlingit counterpart of *Bak'wąs*, the Wild Man of the Woods of the Kwakwaka'wakw, *Gagiid* of the Haida, *Pk'vs* of the Heiltsuk, and *Pooq-oobs* of the Nuu-chah-nulth.

In northern cultures, Land Otter is the most powerful of all guardian spirits and spirit helpers. People believed that Land Otters were originally human, and so possess all the knowledge and power of both species. The tongue of Land Otter is rumoured to know all of the secrets of shamanism. Land Otter is traditionally associated with *shamans* and their practices and appears on their paraphernalia, but may also appear as a personal symbol of an individual's cunning and strength.

Among northern groups, the land otter was the only animal a hunter must never kill. The taboo resulted from the belief that human souls are often transformed into land otters, and perhaps also the belief that of all the animal forms, a shaman is most likely to assume that of a land otter.

The most greatly feared form of *death* is drowning. Land Otters use trickery to capsize *canoes* and acquire the souls of the drowned travellers, carrying them off to the *spirit world* and transforming them gradually into Land Otter people, destined only to cause harm, wander disconsolately and prey on human souls.

L'etsa'aplelana

(Tl:eetsa'apleetlana)

□ L'etsa'aplelana is the name of a Nuxalk supernatural female helping spirit whose primary element is the air. She wears cedar bark rings, which indicate supernatural status and shamanic affiliations. She whirls in the air, emits songs from all parts of her body without

opening her mouth and has the power to throw song into the bodies of other creatures. In Northwest Coast spiritual belief, songs contain magic and the power to effect change.

On *masks*, she has a simple humanoid face with an irregular design identified as a "grease bladder" painted across her face.

Lightning Snake

☐ Lightning Snake is a feathered serpent, a powerful sea monster with a wolf-like head and a long tongue. This creature is a personification of lightning.

Lightning Snakes are typically depicted in pairs, and they are the renowned companions and preferred weapons of *Thunderbird*, who often carries one of them under each great wing. Thunderbird hunts *whales*, using his Lightning Snakes like *harpoons*. A sting by a Lightning Snake renders a massive whale helpless to the subsequent attack of Thunderbird.

Lightning Snake figures and *masks* are particularly prominent in the art and mythology of the Nuu-chah-nulth, who, like Thunderbird, hunted whales. Some Northwest Coast peoples paint depictions of Lightning Snakes

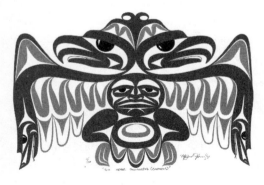

Two Headed Thunderbird (Brothers), print by Maynard Johnny Jr. (Coast Salish): two-headed Thunderbird, Human in centre, Lightning Snakes *(far left, far right)*.

on their canoe bows, and then paint over the designs to hide them from view. The hunter or fisher could then benefit from the spirit power of the creature while the intended prey could not see the dangerous predatory images and flee to escape capture.

Lingcod

(see also Cod)

☐ Nuu-chah-nulth stories attribute eclipses to the Lingcod or the Great Sky Codfish, who occasionally swallows Sun or Moon.

The lingcod was once an important food for the Nuu-chah-nulth. During the *Winter Ceremony*, creatures that were food sources, such as Lingcod, were honoured in a series of dances.

Lingcod *masks*, like those of other fish, show the head in a naturalistic manner, with gills. A fin design may appear on the face, and white *paint* may be used, along with colours.

Lizard

(see also salamander)

☐ Lizards are not common in the art and mythology, and some speculate that the indigenous people were fearful of lizards and snakes, and therefore reluctant to depict them. Lizard is a Tsimshian *crest*.

Lizard-like motifs that are occasionally found in artifacts from Coast Salish regions are generally believed to be representations of salamanders.

Loon

☐ Four species of loon are common winter residents along the Northwest Coast.

Although not a prominent being, Loon features significantly in the art and mythol-

Loon sits atop a mask of Ḵumugwe', chief of the undersea world. EDWARD S. CURTIS PHOTO *(DETAIL),* NAC PA-120423

ogy. Loon is famous for its unique and often haunting voice, and is respected for its knowledge of various realms. Animals with unique vocal talents are held in high regard by Northwest Coast peoples, who traditionally perceive words, voice and song as carriers of power and magic. The ability to traverse various realms such as forest, sea and sky—which Loon demonstrates—is also a characteristic of supernatural power. Loon is associated with *copper* and wealth.

Among the Kwakwaḵa'wakw, Loon is associated with Ḵumugwe', chief of the *under-sea world.* Loon is often shown sitting on the head of Ḵumugwe', in reference to the story of Loon landing on the chief, who is so large that Loon mistook him for an island. Human *chiefs* or *shamans* may likewise wear Loon headdresses. Some Kwakwaḵa'wakw shamans

considered Loon to be one of the most prominent animal spirit helpers.

One Coast Salish legend explains the origin of Loon's unusual markings. Loon once helped an old blind man to escape danger by ferrying the man across a lake on his back. On the journey, Loon also gave the old man back his sight by submerging him in the lake for *four* consecutive dives. After safely landing on the far shore, the old man removed his prized *dentalium* necklace and, in gratitude, tossed it around the neck of Loon. Dark-feathered Loon still wears this gift of decorative white flecks. Perhaps due to stories such as this one, Loon is sometimes cited as a symbol of peace, tranquillity and generosity.

The entire body and head of Loon is usually depicted, generally in a floating posture. The beak is pointed and often open. Sometimes the dramatic markings and spots of the bird's plumage are visible. Loon may be shown carrying young ones on its back, as is its habit in reality.

lynx

☐ Wildcats are very rarely seen in Northwest Coast art, although *shamans* have cited them as spirit helpers. Like cougars, lynx avoid human contact and are seldom seen, which may account for their low profile in Northwest Coast art and mythology.

M

madrona
(see arbutus)

Mamaka
(see Thrower of Sickness)

Man-Eater
(see Baxwbakwalanuxwsiwe')

Man of the Sea
(see Pugwís)

Marmot
(see Groundhog)

Marten

□ The marten is a weasel-like animal indigenous to the Northwest Coast. It was hunted for its fur, used traditionally to make clothing and, later, to bring wealth in trade with foreigners. Marten appears as a being in myths and may occasionally be depicted in the art.

Marten is shown with a long, lean body, and a long, thick tail. It has a small mammalian head, very short ears, and sometimes small sharp teeth.

mask

□ A mask may be worn over the face, or over the entire head and even in some cases over much of the body. Masks are widely used in ceremony and ritual practices, both secular and sacred. The entity or entities represented by the mask confers knowledge, status and/or special powers to the human wearer.

A special type called a *transformation mask* is engineered to open in segments, revealing a second and even sometimes a third face hidden beneath the first.

A mourning mask is danced on the occasion of an individual's funeral. The mask usually depicts an ancestor entity of the deceased, and the dancer wears the mask and sings the associated songs to indicate that the deceased has now assumed this ancestral form.

A mask with subsidiary figures (such as smaller faces embedded in the ears, mouth or eyes, or elsewhere on the face) may indicate transformation or shamanic associations.

Historically, masks were carefully stored most of the year and only brought out for ceremonial occasions.

maskette

□ A maskette is a miniature *mask* worn on a headdress or headband.

materials

□ Traditional art materials include: antler,

beaks (see *puffin*), bone (and various other animal parts), claws (see *Bear*), copper, bark, *feathers*, fur (see *Bear*), grasses of various kinds, hides, hooves (see *Deer, Mountain Goat*), horn (see *Mountain Goat, Mountain Sheep*), paint, *porcupine* quills, roots (especially spruce and cedar), shells (including *abalone, operculum, dentalium*), *skulls*, stone (including *argillite*, which is exclusive to the Haida region, and nephrite, a kind of jade highly prized and traded along the coast), teeth (see *Bear*), oils, *paint*, wool (*dog* and *Mountain Goat*), *wood* (especially yellow and red cedar, but also alder, birch, hemlock, maple, spruce, yew and others).

Materials used after contact include: *beads* acquired from North American, European and Russian traders; commercially made *blankets* and woollen cloth; mother-of-pearl buttons; commercially made *paint*; canvas and paper; glass; silver and gold; cast bronze; semi-precious and precious stones.

Matum

□ Matum is a Kwakw<u>a</u>ka'wakw *warrior* spirit being whose name means "Flyer." He carries a powerful quartz crystal.

Merganser

□ The merganser is a diving duck (sometimes called simply "diver") whose underwater swimming skill leads to its appearance in shamanic art. Merganser is a minor *crest* and appears in Kwakw<u>a</u>ka'wakw family myths.

Merganser is generally identified by a slender bill, which may be slightly hooked at the tip, and a crested head.

Merman

(see Pugwís)

Mink

□ The mink is a semi-aquatic, carnivorous mammal. Mink makes appearances in Northwest Coast Native art but less frequently than many other animal figures. Perhaps this is due to its rarity as a *crest*. Mink is sometimes cited as a *shaman* spirit helper, as it is a creature of both land and water, and has a wily nature. Mink and ermine pelts were used to adorn headdresses and ceremonial garments.

Mink figures prominently in Kwakwaka'-wakw mythology, appearing in stories as the rival of *Wolf*. In some regions, Mink's name translates to "Born to Be the Sun" or "Son of Sunshine" because his mother was impregnated by a sunbeam streaming through a knot-hole in the boards of her house and striking her on the back.

In Nuu-chah-nulth mythology, Mink plays a leading role similar to that of *Raven*. Mink is a primary culture hero, a powerful *Transformer* and one of the pre-eminent beings in the universe. Strong medicine power could be harnessed if a person happened upon a Shaman-Mink singing and shaking a miniature rattle over a rotten log.

In the art, Mink is a weasel-like creature, identified by a short snout; elongated body; long, sharp, teeth; and a fierce expression.

Mitla

(see Winalag<u>a</u>lis)

Moon

□ Moon controls the tides and illuminates the dark night. Moon is also associated with *transformation* and is widely regarded as an important protector and guardian spirit. Because of the powers of Moon, *shamans*

sometimes call upon it as a spirit guide.

Although Moon is not among the most common *crests*, it is a popular image and is frequently depicted in the art. Moon appears in the mythology of all Northwest Coast nations, though Moon's origin varies from story to story, even within one culture.

Most northern tribes thank *Raven* for the gift of Moon, and sometimes stories describe Moon as a chip off of *Sun*, which Raven clumsily dropped.

The Nuu-chah-nulth, whose year features thirteen moons, honour Moon, and his wife Sun, as the most powerful of beings, the bestowers of good luck and plentiful food. This is one of the instances in which Moon is male and Sun is female. Among other groups, personifications suggest that Moon is a female entity, also more delicate and serene than Sun. Nuuchah-nulth purification rituals were customarily undertaken during the waxing of Moon.

The Nuu-chah-nulth sometimes attributed lunar eclipses to the behaviour of a giant Supernatural Codfish or *Lingcod*, who occasionally tries to swallow Moon.

Moon plays a part in the Peace Dance of the Kwakwaka'wakw, in which a human leaves the ceremonial bighouse and returns transformed into Moon. Moon also appears frequently in the *Winter Ceremony* of the Nuxalk.

Moon is often depicted in association with *Wolf* because of the creature's nocturnal habits. Moon frequently appears grasped in the long, straight beak of *Raven*, in reference to the famous myths regarding the theft—and eventual release into the sky—of Sun and Moon by Raven.

Moon is characterized as a rounded face with relatively flat features, often those of a

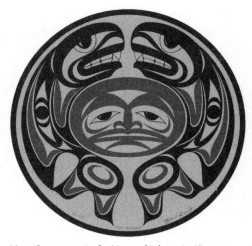

Moon Protector, print by Maynard Johnny Jr. (Coast Salish): Moon in centre flanked by two Killer Whales.

human or a bird. Moon does not have rays, but there is usually a rim or circlet around the circumference. Moon sometimes wears a *labret* (a lower lip ornament), typically represented in graphic form by a circle beneath the lower lip, signifying a feminine aspect. Occasionally, the shape of a crescent moon is represented, and in some pieces both the full and crescent phases are represented simultaneously.

mortal world

(see also cosmos)

□ The mortal world is home to human beings, to familiar creatures such as bears, wolves and birds. There are also some supernatural beings such as *Dzunukwa*, the Wild Woman of the Woods.

Mosquito

□ Mosquito does not often appear in the art, but numerous witty myths describe the origin of this bloodthirsty insect. The stories often feature blood, violence, vengeance,

maddening torture, and the severest of eternal punishments for misdeeds and excessive arrogance.

Mosquito is rarely a *crest*, but one Tsimshian village is named People of the Mosquitoes, and similar associations may exist elsewhere.

Among the Kwakwa̱ka'wakw, Mosquito is called Scratcher. This being appears in interludes designed to bring comic relief amidst more serious ceremonies that range from dramatic to terrifying. Similar comic parts are played by *Bee* and *Wasp*.

The mosquito's blood-sucking habit led to shamanic associations, as some of the ritual practices of *shamans* in treating illness involved actions of a similar nature.

In representations, Mosquito generally has a long, pointy, beak-like proboscis, which may occasionally be curled at the very tip. Sometimes the entire length of the proboscis is lined with teeth. A Mosquito depiction typically emphasizes the head, with a minimal body or no body at all.

mountain

☐ The mainland is dominated by mountain ranges, which in many areas drop directly into the sea. A mountain range also runs down the centre of Vancouver Island. Thus, the people of the Northwest Coast have always been intimately involved with mountains, and it is not surprising that many of the most powerful mythic beings built their dwellings on mountaintops.

Mountain images sometimes appear in the art, and mountains are often personified in myth and art. Among the Kwakwa̱ka'wakw, for example, there is a mountain spirit called Naualakum (Supernatural-Face-Mountain).

Malahat and Cowichan Valley, print by Richard Hunt (Kwakwa̱ka'wakw): *(left to right and top to bottom)* Moon, Wind, Thunderbird, Mountain, Bakwas, Salmon.

A depiction of a mountaintop being may feature a humanoid countenance embedded in a triangular peak shape with a wide base.

Mountain Goat

☐ Mountain goats inhabit open, rocky, high-altitude terrain in the mountainous regions all along the Northwest Coast.

Mountain Goat is a peak-dweller, and so is endowed with special significance as one touching the *sky world*, with a supernatural ability to move through different realms. Its horns, like many other head protuberances, also signify power and supernatural connections. Mountain Goat serves as a guardian and guide, especially to *shamans*.

Mountain Goat is especially important to northern mainland tribes. Stories about

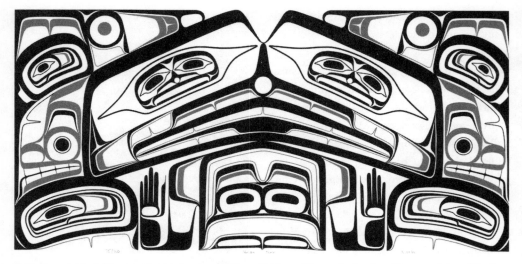

Haida Box, print by Jeff Greene (Haida): box panel design with Mouse Woman (bottom) and Supreme Being of the Sea.

Mountain Goat often focus on the animal's need to revenge the misbehaviour of greedy hunters. Although not generally violent creatures, they are dangerous when incensed by human selfishness and disrespect. They have the power to cause landslides.

Mountain Goat depictions traditionally occur in shamanic, story and *crest* art. Although relatively uncommon in contemporary art, Mountain Goat is an important family crest in some nations.

Hunting mountain goats was a prestigious occupation. In southern Tsimshian tribes, for example, mountain goats and sea lions were the only animals that a *chief* would deign to hunt. Many uses were found for nearly all of the mountain goat's body parts. Hooves, for example, made rattles when tied onto clothing or a shaman's healing stick. Horns were carved into feast *spoons*, amulets and jewellery.

The strikingly intricate and impressive *Chilkat blankets* made by the Tlingit and Tsimshian are traditionally woven with mountain goat wool. Headdresses of goat wool are worn during some Salish ceremonies, and other Salish regalia also features decorative tresses of mountain goat wool.

Mountain Goat is identified by horns, cloven hooves, a short tail and a relatively pointed snout with nostrils. The Supernatural Single-horned Mountain Goat has magic powers (rather like its European counterpart, the unicorn).

Mountain Sheep
☐ The mountains of the Northwest Coast are home to two species of mountain sheep, bighorn and Dall. The horns were made into feast *spoons* and bowls.

Mouse
(see also Mouse Woman)
☐ Mice are quick, cunning gatherers that can get into almost anything and are prone to thievery. For these reasons, Mouse is a useful

spirit helper to the *shaman*. Mouse helps to detect thieves, and, as it is a skilled robber itself, can find and reveal hidden matter and secrets.

Mice are also associated with the communication of magic secrets, both good and evil. In shamanic art, these creatures are depicted near orifices, through which they eat the secrets of supernatural spirits, *witches* or shamans, in order to offer these secrets to their allies.

Mouse depictions are not common in *crest* art, and are also rare in contemporary art. It may be identified by a short body, short legs, and a long thin tail. The snout and round eyes are small, and the ears are relatively short, although they may be proportionately larger than other parts of the body, to express a heightened power of hearing.

Mouse Woman

☐ Mouse Woman's Haida name is Qaganjaat; the Tlingit, Kwakwaka'wakw, and Tsimshian have their own names, and a special place in their mythologies, for her.

Mouse Woman is a rodent-like humanoid being known for her great wisdom, nervousness, powers of speech and cunning. She resides as a guest in households of myth (according to some legends, she is practically a member of *Bear*'s family, for example) and knows all the secrets of her hosts. She is very ancient: *Raven* is her grandson. Mouse Woman often appears as an informant when humans find themselves in strange environments and dangerous predicaments. She is a chief advisor to other worldly travellers.

Haida artist Bill Reid's monumental bronze sculpture, "The Spirit of Haida Gwaii," includes a wonderful version of Mouse Woman: her hair is in a tight knot, and her staring eyes, pointy sniffer and spindly fingers are all tensed in readiness for the next wave.

mussel

☐ Mussels are common on the Northwest Coast, and ancient shell middens indicate that mussels have long been a staple food. In addition to eating the meat, Native peoples found many uses for the purple and blue-black shells. Adzes with blades of mussel shell were used by early woodworkers.

Mussel shells are sometimes used as ornamentation. A *mask* might be framed, for example, with strings of mussel shells serving to represent tresses of hair.

N

name

☐ Names are a valuable form of property, including the right to the names of *houses*, bentwood *boxes*, feast *dishes*, *canoes* and other objects.

Names are conferred during ceremonies that may take place at stages of an individual's life. A person may have a number of names, some of which are used only during ceremonial occasions. Works of art often serve to celebrate and illustrate an individual's names and titles.

'Namxaligu

☐ 'Namxaligu is a giant halibut-like being whose countenance appears frequently on *masks* and who is one of the ancestral founders of and a *crest* of the 'Namgis tribe of the Kwakwaka'wakw. In one story, his forehead held a crystal that gave him the power to kill prey or turn enemies into stone. In another, a giant fish transformed into 'Namxaligu, who built a house with the help of *Thunderbird*.

Nankilslas

(Nanagkilstlas, see Raven)

Naualakum

(see Mountain)

Naxnox

☐ A various group of Tsimshian spirits and their ceremonial *masks* are known as the Naxnox series. Family lineages own the rights to specific Naxnox depictions. The owners of a Naxnox mask might appear in a dance prior to a *potlatch* ceremony, to display ancestral pride and to challenge the audience to identify the represented spirit. A Naxnox spirit dance may at times depict an important family member who is still living. Tsimshian Naxnox conventions spread to neighbouring tribes, such as the Nisga'a.

Nearly-Drowned

(see Pukmis)

North Star

☐ The North Star, which functions as a navigational aid to the sea traveller, is depicted in some Northwest Coast works. It may be shown as a four-pointed star.

northern lights

(aurora borealis)

☐ Although much more vivid and colourful in the north, the spectacular sky phenomenon called the northern lights may sometimes be visible in the southern reaches of the Northwest Coast.

In some tribes, the aurora borealis (literally "northern dawn") was traditionally considered an omen of *death*. With the relatively recent

advent of two-dimensional graphic art on paper and canvas, opportunities to depict the northern lights have increased for Northwest Coast Native artists, but it is still a rare theme. Perhaps the traditional associations with the prophesying of death have some bearing on this absence.

Nuḷamał
(Noohlmahl, Nulmal)

□ The Nuḷamał (Fool Dancer) is a rowdy, supernatural buffoon figure and a source of comedy in both the *Atłaḵim* (Dance of the Forest Spirits) and *Hamat̓sa* (Cannibal Dance) ceremonies of the Kwakwaḵa'wakw. The Nuḷamał dancer and Grizzly Bears are the messengers of the Hamat̓sa and are also ceremonial police officers, strictly maintaining order but occasionally causing violent disorder in the house. They may be spurred on by any nasal references, and are known to rudely throw theatrical snot on members of the audience. The Nuḷamał is known to be volatile, pushy and obnoxious.

The dancer's clothes are dirty and tattered. In theatrical performances, the stage might be "slimed" with a mucous-like substance, supposed to have flowed from the oversize nose of a Nuḷamał. Some depictions feature cloth stuffed up the nostrils of the creature, ostensibly in a futile attempt to stem the copious emissions of snot. The Nuḷamał is depicted with an absurdly large nose, which produces powerful magic mucous; the face has a silly, crazy, twisted expression.

O

Ocean

□ Below the surface of the sea is the complex and diverse *undersea world*, full of creatures both natural and supernatural, and with political structures and hierarchies resembling those of humans. Below the ocean floor are villages resembling those on earth, where sea creatures remove their aquatic appearance and walk about looking like humans.

Ocean is often personified and functions as a family *crest* among some Northwest Coast groups. Ocean phenomena such as Riptide and Whirlpool also are family crests in some groups.

Ocean has the power to wash away evil, but also has the power to bring great harm to coastal dwellers. Ocean is a mighty being who demands respect and supplications.

Visual depictions of Ocean may have both human and marine features. A wave design may feature a humanoid face, or a humanoid portrait may have wave or marine motifs. Artists may choose from a wide variety of motifs and design elements in their representations.

Octopus

(Devilfish)

□ The octopus is a remarkable, unique, eight-armed sea creature. It has the ability to change colour, shape and even texture, as well as to eject dark ink in self-defence.

Octopus is common in shamanic art, undoubtedly because of its amazing transformational abilities. It is also a *crest* in some regions—among the Tsimshian Eagle *clan*, for example. Among the Haida, Octopus features in legend and myth, but is not a crest.

Myths speak of giant devilfish monsters who occasionally devour canoes and sometimes even entire villages. Octopus is a powerful potential sea spirit helper, often shown in complex compositions involving other creatures. In some tribal cultures, eight is considered a magic and auspicious number, which adds to the appeal and power of Octopus. Octopus is a servant of *K̲umugwe'*, chief of the *undersea world*, and is also symbol of great wealth in Kwakwa̲ka'wakw mythology.

Octopus is identified by long tentacles that have round marks, often in double rows, representing suckers; a fluid, invertebrate body; round, high, head; large eyes; and a short beaklike mouth. Tentacles and rows of suckers often appear elsewhere on it as decorative motifs or as visual puns; they may also form anatomical elements (such as eyebrows) on the faces and bodies of other creatures, to indicate transformational abilities and shared spirit power.

operculum

□ Operculum (plural opercula) is a piece of

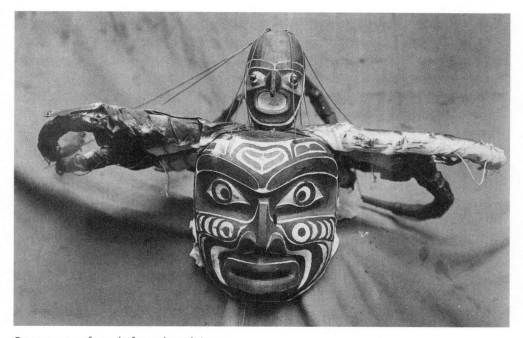

Octopus on top of a mask of an undersea being. EDWARD S. CURTIS PHOTO, NAC PA-120424

shell that covers an orifice in some species of mollusc such as slugs or snails. It is ovular and whitish. Artists frequently inset rows of opercula to represent teeth in *masks* or as a decoration on *boxes* and *dishes*.

Orca
(see Killer Whale)

Otter
(see also Land Otter)
☐ Two otter species live along the Northwest Coast. The sea otter lives in ocean waters, and its thick warm pelt formed the basis of the early fur trade along the coast. The river (or land) otter lives on land, though it forages for food in quiet bays and river estuaries.

Sea otters are challenging prey, and hunting them was a prestigious activity. Sea otter pelts were highly prized and widely traded, contributing to a dramatic increase in wealth along the coast after European contact.

The otter is intelligent, resourceful and agile, using its forepaws like hands. It is also among the most playful of all creatures, and otter images often serve as symbols of laughter and lightheartedness.

Among Coast Salish people, abstract images that appear to be Otters were traditionally popular on house posts. In the art today, Otters are less frequently depicted than many of the other animal motifs, despite the very important place the creature traditionally holds in the culture. Perhaps its lack of presence in contemporary art may be attributed to its rarity as a *crest* animal and the decline of art produced for shamanic purposes.

Otter representations are identified by

long, streamlined, bodies, often in swimming postures, with legs and feet tucked in; a long, thick tail; small ears; wide eyes; blunt head; a strong mouth, often with sharp teeth; and a short, rounded snout. Traditionally, Sea Otter was shown on its back, often grasping a shell or a sea urchin. Otter is an accomplished fisher, and may be depicted with a fish.

Owl

□ Among owl species living on the Northwest Coast, the great horned owl and western screech owl are year-round residents, while the snowy owl is a winter visitor.

The owl is a nocturnal hunting bird, a strong and silent flier with acute hearing and vision, and a haunting call. As in other cultures, Northwest Coast people believe that Owl has great powers of wisdom, foreknowledge and perception. White Owl is a family *crest* in some regions.

Owls are powerful spirits whose presence often signifies the approach of *death*. For many Kwakwaka'wakw, Owl symbolizes darkness and ancestor spirits, and a dying person will hear an Owl call his or her name. In Tsimshian traditions, an Owl flying overhead can foretell, or even cause, the death of those below.

A *witch* may appear disguised as an Owl, but an Owl may also aid a *shaman* in pursuit of the good.

Perhaps because of its association with death, Owl is infrequently depicted by artists. The Gitxsan village of Kispiox, however, features many Owl images on its totem poles.

Owls are identified by large, round eyes; a

Horned Baby Owl, print by Ron LaRochelle and Irene LaRochelle (Haida).

very short, hooked beak which comes to a V; and pointed ears, which may be prominent to emphasize acute hearing.

Oystercatcher

□ The oystercatcher is a long-beaked shorebird with a striking appearance: it has black feathers, yellow eye markings, and a red beak. Its status as a border-dwelling creature (one that moves between land and sky) gives it special significance, and Oystercatcher's presence in a work of art traditionally indicates shamanic associations.

In the art, an Oystercatcher spirit helper typically carries other beings on its back. The Oystercatcher *rattle*, decorated with *witch* imagery, is one of the basic implements of the Tlingit *shaman*. Such rattles appear among the shamanic paraphernalia of other tribal groups as well.

Oystercatcher is often depicted with a long, curved neck; a straight bill; and webbed feet tucked up into the body. Oystercatcher images are easily confused with those of *Crane* and *Cormorant*.

P

paddle

□ The wooden paddles used to propel *canoes* are made of a variety of *woods* and are often decorated with carving or painting. Model paddles, as well as representations of paddles, frequently appear in both two-dimensional and three-dimensional works of art.

People use paddles as flags and signals in some ceremonial contexts, and the position and formation of paddles can communicate messages over a long distance across the water.

Gifts and offerings to supernatural entities of the *undersea world* are commonly offered from the blade of a paddle.

paint

□ Before European contact, the artist's palette typically consisted of the following colours: black (primarily made from soot, charcoal or magnetite), red (from hematite), mustard yellow (from ochre, an earthy iron ore), and blue or bluish-green (from celadonite or sometimes from a corrosion of copper). Traditional pigment bases included saliva, dried salmon roe, water and various kinds of oils.

Paint pots and brushes were sometimes decorated. People commonly decorated implements in an attempt to magically increase their effectiveness and power.

Early in the nineteenth century, fur traders began to offer powdered vermilion from China that produced a bright red. Also during the nineteenth century, bright yellow and white were added to the palette.

Traditional Haida, Tsimshian, Tlingit and Heiltsuk colours were black, red and blue. Black, white and red were the three main traditional colours used by the Kwakwa̲ka̲'wakw, who also showed a preference, in historical times, for green and mustard yellow. Coast Salish peoples may have traditionally favoured blue and red. The Nuxalk used blue, yellow, white, red and black.

Today, the traditional colours are still popular, but artists often take the opportunity to work with the much wider variety of available hues.

petroglyph
(and **pictograph**)

□ There are numerous rock art sites, some of which are prehistoric, in the Northwest Coast. Petroglyphs (carvings) and pictographs (drawings) often depict animals, humans or supernatural beings. Some design elements, such as *rayed hair* and *skeletal* imagery, suggest shamanic themes. Other designs seem to represent *Coppers* and European ships.

Occasionally, artists today reproduce or draw inspiration from these rock art forms.

pictograph
(see petroglyph)

pilot whale
(see Blackfish)

pipe
(and **tobacco**)
□ Smoking was aboriginal in the southern nations of the Northwest Coast region, but was introduced to the northern nations by Europeans (originally, tobacco was chewed or used in the form of snuff). The production of *argillite* pipes, often elaborately carved with representations of *crests*, myths and legends, subsequently became very common.

According to some, Haida Gwaii's only indigenous domesticated plant was a variety of tobacco, now extinct. Tobacco is a traditional gift, offered to recipients both secular and divine.

Pḵvs
□ Pḵvs is the Heiltsuk counterpart of *Baḵwas*, the Wild Man of the Woods of the Kwakwaḵa'wakw, *Gagiid* of the Haida, *Land Otter* of the Tlingit, and *Pooq-oobs* of the Nuu-chah-nulth.

Pooq-oobs
(Spirit Whaler)
□ The Nuu-chah-nulth and the Makah people, who hunted whales, both have stories about a person who is lost at sea while hunting a whale and is transformed into a spirit being. Pooq-oobs has many counterparts: *Gagiid* among the Haida, *Baḵwas* (the Wild Man of the Woods) among the Kwakwaḵa'wakw, *Pḵvs* among the Heiltsuk, *Land Otter* among the Tlingit.

porcupine
□ Before modern tools became available, porcupine hair was a primary paintbrush material for Northwest Coast artists. The northern practice of using porcupine quills to decorate ceremonial clothing may have been borrowed from subarctic inland tribes.

The porcupine is not often depicted in the art but does appear in stories.

Porpoise
(see Dolphin)

potlatch
□ The word "potlatch" comes via the Chinook Jargon, a composite trade language, from the Nuu-chah-nulth "pa-chitle," meaning "to give." A potlatch is the important ceremony that consolidates the social and legal fabric of Northwest Coast cultures, which have an oral tradition and no written language prior to contact.

Potlatches customarily occurred in the winter, when people were less occupied with the business of securing food. Wealthy and high-status families hosted elaborate ceremonies and feasts, at which a wide variety of announcements, proclamations and initiation rites were performed and communicated. The guests, who were responsible for witnessing and remembering the claims and events taking place, were presented with gifts as payments for their important role.

At the time of European contact, potlatching was more prevalent among northern tribes, although it was practised among southern nations as well. The new wealth and better tools introduced through the fur trade stimulated an increase and elaboration of pot-

latching. Competitive potlatching increased as warfare decreased. This era (late eighteenth to late nineteenth century) is often called the golden age of Northwest Coast art.

European settlers often found potlatching incomprehensible, as the extravagant gift-giving ran contrary to their notions of property and common sense. They did not understand the function of the potlatch and believed that the highly competitive nature of the practice would lead to corrupt and even criminal behaviour in pursuit of the material goods required for distribution. The Canadian government and Christian missionaries conspired to make potlatching and the *Winter Ceremony* illegal. This was one of many measures European settlers and their institutions took in efforts to assimilate Native people and undermine their culture. The restriction against potlatching and the Winter Ceremony lasted from 1884 to 1951.

Although some tenacious and rebellious groups continued the practice, the potlatch ban constituted a grave threat to the survival of the culture. There was a dramatic decrease in production of art, and a significant interruption in the transference and remembrance of property, myths and stories.

Today, artists are once again creating pieces either for performance, display or distribution at potlatches. Potlatch conventions have changed to meet the needs of modern societies, but the ceremony endures and continues to play an important part in the lives of Northwest Coast Native peoples.

power board

(duntsik)

☐ The power board of the Kwakwaka'wakw

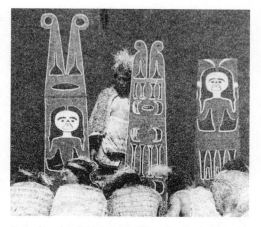

Power boards raised during a *Winter Ceremony* dance (Kwakwaka'wakw). EDWARD S. CURTIS PHOTO *(DETAIL)*, NAC C-034790

was a series of hinged boards, carved with perforated designs and painted, usually with a representation of *Sisiyutł* (the double-headed serpent), assistant of *Winalagalis* (War Spirit). During the Winalagalis dance, the power board was raised so it stood about 3 metres (9 to 10 feet), then was collapsed again.

prayer

(see also Creator)

☐ In traditional Northwest Coast spiritual belief, all beings and all things have a soul and a supernatural aspect. Asking and thanking these spirits for their benevolence and guidance was the practice of individuals and groups, in both public ceremony and private prayer. People offered not only words of prayer but also gifts of food, precious substances and beautiful ornaments.

Property Woman

(see also Dzunukwa)

☐ Property Woman is a Tlingit supernatural creature who dwells in the woods. Like her

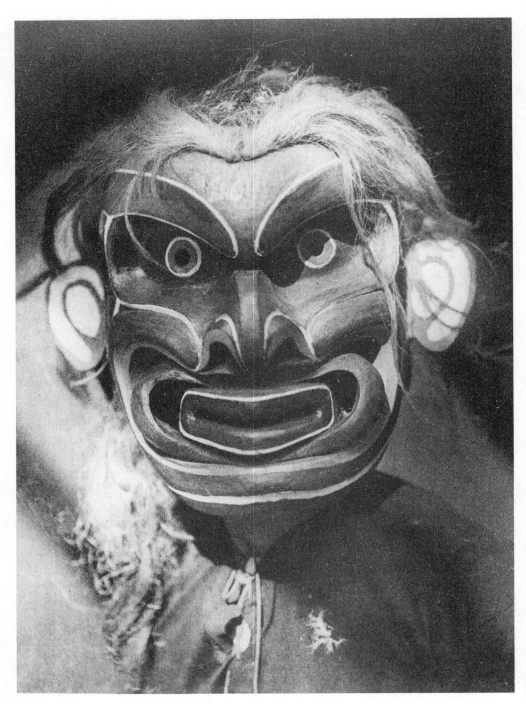

Mask of Pugwís (Kwakwa̱ka̱'wakw). EDWARD S. CURTIS PHOTO, NAC C-016783

southern counterpart *Dzunukwa*, she may bring great harm to the ignorant, or great fortune to individuals who know how to deal with her.

She is believed to eat only shellfish and seaweed during one *moon* phase, and Tlingit *shamans* are permitted to eat only these foods during that same moon.

puffin

□ The tufted puffin is the species that traditionally breeds throughout the Northwest Coast, while the horned puffin is usually only found farther north.

Puffins are diving water birds. Images of them are sometimes found on shamanic art objects, symbolizing remarkable journeys through mysterious watery realms.

Puffin beaks were traditionally used to ornament clothing and artifacts, and in bunches as *rattles*.

Pugwís

(Man of the Sea, Merman)

□ Pugwís is a Kwakwaka'wakw undersea spirit in human form. Pugwís is depicted with a fish-like face, round eyes in well-defined round sockets, gills, prominent, rounded contours on the face; and two large, beaver-like front teeth. Sometimes *Loon* sits on top of his head.

Pukmis

(Nearly-Drowned)

□ Pukmis is a Nuu-chah-nulth supernatural being. A malevolent spirit who is fast moving and dangerous to seafarers, Pukmis is depicted in white, with claws and protruding eyes.

Q

Qaganjaat
(see Mouse Woman)

Qominaga
(see Copper Woman)

Qumugwe
(see Ḱumugwe')

Quolus
(see Ḵulus)

R

Raccoon

☐ Among the Kwakwa̱ka'wakw, Raccoon is part of the *Atła̱kim* (Dance of the Forest Spirits). In the art, Raccoon is characterized by a black band across the eyes and painted whiskers.

Rainbow

☐ Personifications of Rainbow occur frequently in Northwest Coast art and myth. Many Nuxalk *masks* were of elements such as *Echo, Moon, Sun* and Rainbow, as well as birds and flowers.

Among the Haida, legend tells that the chief of all the supernatural forest beings appeared one day in the guise of a rainbow. Since this chief was a spirit with essential "Raven power," members of the Haida Raven *clan* could thereafter claim Rainbow as a *crest*, bestowed on their lineage by this powerful being.

One Haida Rainbow mask features a deeply arched, face-framing headdress.

rattle

☐ Along with *drums*, rattles are the predominant percussive instrument used in shamanic and ceremonial contexts. Rattles appear in a variety of shapes and sizes, and are often finely carved or painted. Representations of rattles sometimes appear in the art, particularly in the grasp of *shamans, chiefs,* and dancers.

A *Raven* rattle—carved in the shape of the bird—generally indicates a chiefly or high-ranking figure. A *shaman's* rattle is double-sided, symbolizing life and *death*, or the veil between the human and spirit worlds. Traditionally, rattles and their noises may contain magic. The sound of rattles is used to calm and tame wild dancers in some ceremonial performances.

Raven

(see also Cannibal Raven, Sea Raven)

☐ The raven is a large bird, with blue-black or jet black plumage, often mistaken for a crow, but is much larger. Ravens, American and northwestern crows, and Steller's jays are four representatives of the crow family found throughout the Northwest Coast region. Ravens are infamous for thievery and for mischievously moving objects from one place to another.

The white raven is a rare genetic occurrence of which people of the Northwest Coast are particularly fond. These white ravens are believed to be good omens and magical. Some people believe that bad luck will befall anyone who harms a white raven.

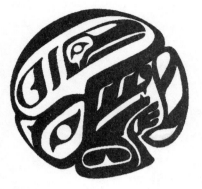

Wolf, ink on paper by Clifton Fred (Tlingit): Raven *(top)* and Wolf *(bottom)*.

Raven is one of the most important beings in Northwest Coast art and mythology, although the nature of his role varies from one culture to the next, and his predominance diminishes from north to south. To the Haida, Tlingit and Tsimshian, Raven is the original organizer, *Trickster, Transformer*, teacher, catalyst and chief spirit. He is also a relentless schemer and practical joker, lustful, impulsive, cunning, shameless and without remorse.

Raven has the power to transform both himself and other beings. He can even change animate to inanimate matter, and vice versa. He is the most accomplished Transformer of all. Sometimes he is blamed for impregnating women, by becoming a speck of dirt or a pine needle in the water they drink.

Raven has the power of prophecy— in Haida, he is called Nankilslas, or Nanagkilstlas, meaning "He-Whose-Voice-Is-True." And, true to Raven's slippery character and contradictory aspects, this name is elsewhere translated as "One-Who-Gives-Orders." Although Raven is supremely creative and productive, he is not the supreme *Creator*; he is the Creator's chief and original agent.

The cycle of Raven myths is customarily accessible to all, unlike most stories, which are the property of certain families. In some cultures, Raven stories may be divided into two categories, one that is "sacred" and the other "everyday."

In stories, Raven is intelligent, curious, innovative and resourceful, yet selfish, greedy, deceitful and mischievous. He always follows his appetite, and consequently is often in trouble: in fact, that is when he does some of his best creative work. Among many other achievements, Raven determined the order of things in the world as we know it; secured the blessings of *Fire*, water, *Sun, Moon*, stars; and discovered humankind and all other creatures.

The Kwakwaka'wakw attribute the discovery of fire to Raven, along with the operation of the tides and the alternation of day and night. In some Haida traditions, Raven's voice and "ruffled and puffed" appearance, like *Owl*'s call and appearance in many Kwakwaka'wakw traditions, foretells the death of an individual. Despite these important shamanic roles, Raven is much more often associated with story and *crest* art.

In Nuu-chah-nulth stories, Raven is not the Transformer but the ultimate glutton. His Chief Transformer position is here filled by either *Mink* or *Snot Boy*. Coast Salish myths speak of Raven as a mischievous Trickster, but not as the prestigious Transformer.

Raven and *Eagle* are the two main *clans* of the Haida and of some northern Tlingit peoples. With *Wolf*, Raven is one of two main clans among the other Tlingit groups. Among most Tsimshian groups, Raven is one of four main clans. Among the Heiltsuk, Raven is the

highest-ranking group, followed by Eagle, Killer Whale and Wolf.

In the art, Raven is characterized by a strong, straight, tapering beak, sometimes very slightly curved or squared at the tip. If Raven has ears, they are not prominent, and his long wings are often folded close to his body. He is often painted black.

The Raven *mask* used by the Kwakwaka'-wakw for ceremonies does not have a cedar bark fringe, but the Cannibal Raven mask for the *Winter Ceremony* or *Hamatsa* (Cannibal Dance) does. Raven also occasionally appears in examples of shamanic art, as he originally gave the secrets of shamanism to the people.

Raven of the Sea

(see Sea Raven)

Ravenstail robe

(see also blanket)

☐ The Ravenstail is an ancient weaving technique on the Northwest Coast. Ravenstail robes are woven on the same type of loom as the *Chilkat blanket*, but they are woven edge to edge rather than in vertical sections. Ceremonial robes made using this technique are rare because the making of them stopped early in the contact period. They are predominantly black and white, with a bit of yellow.

Red Cedar Bark Dance

(see Winter Ceremony)

Red Snapper

☐ Red Snapper is a bottom-feeding, large-eyed, spiky fish that appears occasionally in the art and may represent a spirit helper.

Red Tide

☐ Red tide is a toxic marine organism that often visits Northwest Coast shores during summer months, sometimes causing shellfish to become poisonous. Like most other aspects of the environment, Red Tide is personified in Northwest Coast art and myth. Spirit of the Red Tide generally has a human countenance with marine motifs, a malevolent expression and red colouring.

Reef

☐ A marine reef may be endowed with history and personality. One Haida myth tells the story of a woman who mated with *Killer Whale*, suffered her human husband's wrath, and finally entered the sea and transformed herself into a reef.

reincarnation

☐ Traditional belief in reincarnation is widespread among Northwest Coast groups. Spirits of recently deceased ancestors were known to re-enter the family lineage through subsequent births. Children are observed closely for signs indicating possible past life identities, and the art often illustrates and expresses belief in rebirth and regeneration.

Returned from Heaven

(see Dhuẃláx̌a)

Rich Woman

(Komunokas, Qominaga; see also Copper Woman)

☐ Rich Woman, danced by a female, is one of the initiate's two attendants during the *Hamatsa* (Cannibal Dance) ceremony of the Kwakwaka'wakw.

ridicule

☐ The ridicule figure or *mask* is simply meant to mock or shame a rival, and thereby enhance the status of the owner.

One style of ridicule mask depicts a human face with features on only one half of the face: the other half is blunt and blackened, as if burned. This refers to a confrontation between rivals at a *potlatch*: the wealthy host throws extravagant amounts of valuable *eulachon* oil on the fire to fuel the flames, and the rival, who is seated closest to this inferno as an "honoured guest," must not move away, because to do so is to admit inferior strength, status and wealth. In order to "save face," the rival literally loses his face, as the fire melts off one side of it.

An emaciated ridicule figure might not represent the actual physical appearance of the rival. The appearance of starvation symbolizes poverty, so the emaciated figure indicates "this person is a failure." Grievances could also be voiced in song form, without attendant masks or props.

A common grievance involves accusations of usurpation of rights to *crests*, dances, stories or other property. It was, and in many cases still is, a serious offence to "steal" a story or an image that traditionally belongs to another individual, family, lineage or clan.

S

salamander

(see also lizard)

□ Salamanders, which are common in the Northwest Coast region, are uncommon in the art and mythology. In some areas, however, the Coast Salish depicted them in wood carvings. Some sources claim that indigenous peoples may historically have been somewhat fearful and wary of salamanders, along with *snakes* and *lizards*. This dislike might help to explain their rarity in the art.

Salish blanket

(see also blanket)

□ Salish women were renowned for their woven rugs and blankets, made primarily from *mountain goat* and *dog* wool. A breed of small, white dogs (which apparently became extinct around the middle of the nineteenth century) was kept specifically for the production of wool. The blankets were usually solid and undecorated, although some had a geometric border or plaid-like continuous pattern, and a few featured elaborate designs twined into the weft. Bits of feather and bark might be spun into the wool for texture and colour. This tradition nearly became extinct, but was successfully revived in the 1960s.

Salmon

(Swimmer)

□ There are five species of Pacific salmon: chinook (also called spring, king, tyee, quinnat), coho (silver, silverside), sockeye (red, blueback), pink (humpback) and chum (dog salmon). All five species hatch in freshwater, mature in the sea, then return to their freshwater homes to spawn and die. They differ in migratory and feeding habits, length of life cycle, size, appearance and flesh quality.

Salmon are honoured and celebrated by all coastal peoples: the fish serves as a powerful symbol of regeneration, self-sacrifice and perseverance.

Shortages of salmon are traditionally attributed to human disrespect and refusal to listen to and live by the wisdom of the elders. Many legends express the importance of appreciating the Swimmer and observing traditional rites of respect, such as placing all of Salmon's *bones* back into the rivers or the sea after eating. If this ritual is not observed, Salmon will not return, or will return dismembered and deformed.

Some myths tell about people who were kidnapped by Salmon and eventually returned to their villages with secret knowledge that enabled them to become great *shamans*. Other

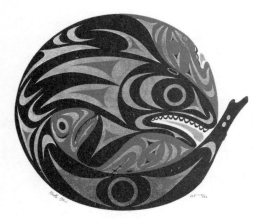

Peace Feast, print by Klatle-Bhi (Kwakwa̱ka̱'wakw and Coast Salish): Killer Whale *(top)*, Salmon *(bottom)*, canoe, spirit guides.

myths speak of shamans and/or chiefs voyaging to the *undersea world* villages of the Salmon People to secure vital knowledge and power necessary for the survival and success of their own people.

In many Northwest Coast cultures, Salmon are associated with *twins* and are therefore usually carved in pairs. Any twin could claim Salmon as a *crest*, regardless of lineage.

Salmon is especially prominent in the art and mythology of the Coast Salish people, who use it as a unifying symbol of their nation.

Scholars think that in some regions, the high status and respect accorded to women may relate to their role in the salmon economy. The skill and labour involved in preparing the fish was greater than that involved in catching it. Women were the keepers of the tribe's most treasured catch and cache.

Salmon once ran in nearly every stream and river along the Northwest Coast. Certain species have drastically fallen in number, and all are threatened by human encroachment.

In the art, Salmon is identified by short fins, round eyes, downturned mouth, long body, gills, scales and a moderately large, slightly bifurcated tail. Curly ears indicate the presence of a Supernatural Salmon.

Salmon Woman
(see Fog Woman)

sandpiper
(snipe)
□ The sandpiper is a long-legged, wading shorebird. Like other border-dwelling creatures, it is admired for its ability to live in more than one realm. It is rarely depicted in the art.

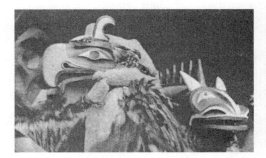

Masks of Sculpin *(right)* and *Thunderbird* (Kwakwa̱ka̱'wakw). EDWARD S. CURTIS PHOTO *(DETAIL)*, NAC C-020839

Sculpin
(see Bullhead)

sea anemone
□ Uncommon but sometimes depicted, the sea anemone design may resemble a spiky rosette. The sea anemone is often brightly coloured and the many tentacles make it resemble some flower varieties.

In the art of the Kwakwa̱ka̱'wakw, a decorative sea anemone motif will often appear in association with *K̲umugwe'*, chief of the *undersea world*.

Sea Bear

(Sea Grizzly)

☐ Sea Bear is a supernatural being of the *undersea world*, a skilled whaler revered by hunters. It is closely associated with *Sea Wolf* and the powerful and important *Snag*, who lives at the bottom of the sea. The presence of Sea Bear motifs may indicate prowess as a hunter and also a willingness to accept responsibility for holding up the world.

Sea Bear is a supernatural hybrid that has the head of a bear combined with marine features such as a whale tail and fins.

Sea Eagle

☐ Sea Eagle is a supernatural being of the *undersea world* with *Eagle* characteristics. Among the Kwakwaka'wakw, Sea Eagle is called Kwigwis, and serves as a family *crest*. Elaborate, feathered, full-body costumes may be worn for performances of this ancestor myth.

Sea Frog

☐ Haida cosmology identifies the original home of *Frog* as the sea. In Haida mythology, Sea Frog is an amphibious marine creature who makes its home at the bottom of the world, and who holds the secrets of wealth and transformation. Sea Frog is associated with *Taangghwanlaana*, the One in the Sea, from whose house flow all the riches of the world.

Sea Lion

☐ The sea lion is a large and powerful mammal, a skilled fisher that commands respect. The two species on the Northwest Coast are the California and the Steller's sea lion.

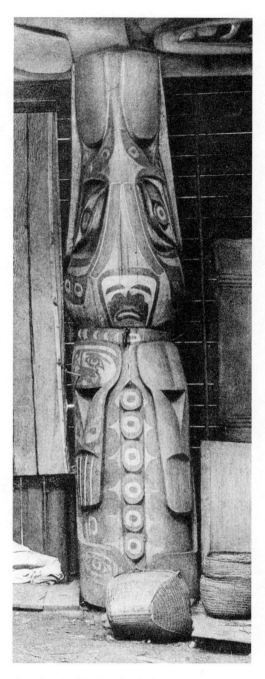

One of a pair of Sea Lion interior *house* posts (Kwakwaka'wakw). EDWARD S. CURTIS PHOTO *(DETAIL)*, NAC C-030190

According to the Kwakw̱a̱ka'wakw, Sea Lions function as house posts and hold the prestigious position of head guards at the house of K̲umugwe', chief of the *undersea world*.

Sea Lion is identified by its mammalian head, which may appear bear-like; a rounded snout with whiskers; short, often sharp, teeth; small ears; a thick body; and flippers at the sides and/or rear. Generally, the presence of teeth helps to differentiate Sea Lion from *Seal*. Also, Sea Lion's ears are usually pointed, and it has long whiskers and large flippers.

Sea Otter

(see Otter)

Sea Raven

(Raven of the Sea)

□ Sea Raven has special powers in the ocean, being the equivalent of *Raven* in the *undersea world*. He is sometimes depicted as a Raven with *Killer Whale* fin design elements to indicate his marine nature.

sea urchin

□ The sea urchin is a marine echinoderm that has a flattened, spherical shell with many fine spines. The sea urchin and its roe are a traditional food of Northwest Coast groups.

Artists sometimes depict a sea urchin in the grasp of *Sea Otter*, especially when Sea Otter is shown floating on its back. The sea urchin generally appears in conjunction with other figures; it is not important on its own. Artists sometimes incorporate colourful sea urchin motifs in marine scenes.

Sea Wolf

(Waasghu, Wasco, Wasgo)

□ Sea Wolf is a prominent Northwest Coast being of the *undersea world*. Called Wasco or Wasgo by the Haida, this giant sea monster has the head and tail of *Wolf*, with *Killer Whale* elements such as fins and a blowhole. Wasco, who hunts Killer Whales and brings them home to feed his family, is a popular being in stories and a favoured spirit guide among Haida fishers.

Sea Wolf is an alternate form of the undersea world beings *Sea Bear* and *Snag*, and as such is one of those who literally carry the world on their backs in Haida mythology and cosmology.

Seal

□ The common Northwest Coast species is the harbour or hair seal. Seal represents wealth and plenty. Among the Kwakw̱a̱ka'wakw, K̲umugwe', chief of the *undersea world*, is also known as Protector of the Seals, indicating the special status reserved for these creatures. Seals were traditionally an important resource, providing food, oil (for fuel), and tough, waterproof hides that could be fashioned into useful items such as whaling floats.

Seal appears rarely in the art as a *crest*, but appears often in stories. Seal, like *Beaver*, is an image often found gracing a finely carved bowl.

Seal is often rendered more realistically than other creatures, with round features similar to those of Sea Lion, but without whiskers, pointed ears or visible teeth. Seal is often depicted with *Salmon*, for Seal is admired as a skilled fisher.

seaweed

□ Seaweed was commonly gathered and dried for food, generally in the spring. Long,

hollow kelp tubes and bulbs were used to store oil. They were also ingeniously used during theatrical performances: the tubes were hidden from the audience's view and used to project sound for a "disembodied voice" effect. Alternately, kelp tubes were sometimes used as a trumpet-like wind instrument.

Kelp may appear as a *crest* or name: for instance, one Coast Tsimshian group is named People of the Kelp.

Seaweed motifs sometimes appear in Northwest Coast artworks.

shaman

(see also rattle, soulcatcher)

□ A shaman may be male or female, although male shamans are far more common. The profession is inherited, or sometimes ordained by signs and omens. A shaman functions as a mediator, healer, visionary, guide and counsellor. He or she accesses spirits and essences of things both animate and inanimate, and maintains links between the many worlds of the *cosmos*.

Primarily, the shaman doctors illness, but also secures food supplies, predicts *reincarnations*, ferrets out *witches*, confers good and bad luck, finds lost items, accompanies war parties, maintains proper balances within individuals and harmony of people with nature. The shaman treats illness as evil in the body, which is the result of thoughts and behaviours in conflict with nature. Medicinal plants and herbs may be used in treatment, along with magic.

The shaman has the ability to travel through the many worlds of the cosmos, which are connected by a central axis (some-times symbolically represented by a decorated pole). Also, the shaman is capable of transforming into beings, both natural and supernatural, from any of these realms.

The shaman, especially when depicted in *death* poses, has a gaunt face and prominent ribs. Such conventions may suggest intimacy with death, or refer to the shamanic practice of fasting during vision quests and other ascetic practices.

Alliances with animal and ancestor spirits empower the shaman; these alliances are formed during vision quests and periods of isolation, trances, dreams and ritual supplications. Animal spirits are vitally important; animals are thought to have knowledge and power essential to humans. Shamans use special songs to summon helping spirits.

The shaman appears in public ceremonial performances and also performs private rituals, often at designated sacred sites such as cave sanctuaries. Sometimes a shaman performs feats of magic, such as walking on water, displaying immunity to fire, ventriloquism and escape acts.

A shaman's regalia—cape, necklace and crown—are of great importance. Hair is a source of power and therefore is never cut or combed. A shaman's tunic and dance apron are often decorated with spirit guide motifs and may be anointed with valuable oils. The necklace and crown are made of claws, *bone*, stone, *wood* or *cedar* bark. Bone ornaments are particularly sacred, as bones are the most enduring body part and are thought, therefore, to be the source of life. Wide neckrings made from hemlock or cedar bark were passed over the raised body of the patient in a cleansing ritual.

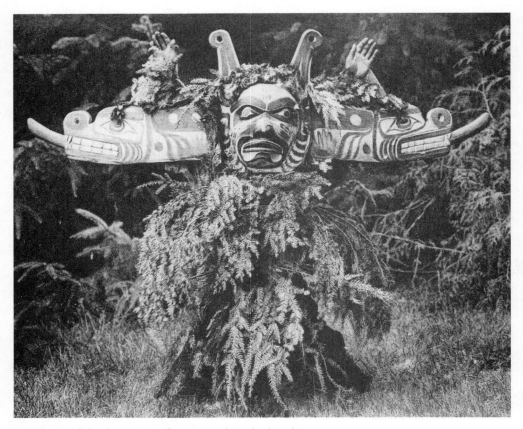

Sisiyutł is revealed in this open *transformation mask* (Kwakwa̱ka̱'wakw). EDWARD S. CURTIS PHOTO, NAC C-034788

The shaman has special *boxes* to hold amulets and implements such as effigies, healing sticks, *soulcatchers*, *rattles*, *feathers*, down, throwing sticks, staffs and *drums*. The shaman's materials are infused with magic and are not to be touched by outsiders. Often, the paraphernalia is buried with the dead shaman.

Tlingit shamans used *masks* more frequently than those of other groups; as they remained mostly in place while performing ceremonies, their masks had no need for eyeholes.

Traditionally, shamanic art is most common among the Tlingit, Haida, Tsimshian and Coast Salish.

Shark
(see Dogfish)

Sisaok
(Sisauk)
□ The Sisaok is a Nuxalk dance ceremony comparable to the *Dhuu̓láx̌a* of the Kwakwa̱ka̱'wakw. The successful Sisaok initiate earns the right to display *crests* and ancestral *names* and perform the associated stories, songs and dances. The dance uses *masks* of natural elements and forces such as *Earthquake*, *Sun*, *Moon*, *Echo* and others, as well as of birds and flowers.

Sisiyutł

(Sisioohl, Si'siul, Sisiutl, Siskiyutl)

□ Sisiyutł is a powerful, terrifying double-headed serpent that guards the house of the sky people. Sisiyutł symbolizes duality and contradiction: it is a death-dealer but can also bestow power. It can transform into a fish or a self-propelled *canoe*, and its glance can kill or turn an enemy to stone.

Sisiyutł is also a spirit helper who is called upon to make *warriors* powerful and invulnerable. Warriors wear headbands and belts with the image of Sisiyutł. In the Winalagalis (War Spirit) ceremonies of the Kwakwaka'wakw, Sisiyutł is one of the warrior's attendants, called forth by the *Tuxw'id* (female war dancer).

After catching a Sisiyutł, a person must throw sand on it, not touch it directly, tie it securely and never have it in the house. Keeping it in water produces potent medicine; washing with the water brings health and longevity. Families that claim Sisiyutł as a *crest* may own parts of its body, which bestow great powers on the bearer. Bits of glittery mica found on the shore are sometimes called Sisiyutł scales.

Sisiyutł is usually shown horizontally as a double-headed serpent, the heads at each end in profile displaying wolfish features, long tongues and a single curly horn-like appendage. The creature's middle is usually a human-like face, with two curly horns. Among the Nuxalk, Sisiyutł is noted for its well-sculpted features and deep blue colouring. The image of Sisiyutł, in abstract form, also appears on *power boards*.

Skate

□ A species of fish shaped roughly like a diamond and fairly flat. Among the Haida, Skate is a *crest* of the Raven *clan*.

Skils top a *Raven* pole (right) at Masset, Haida Gwaii, c. 1890. R. W. REFORD PHOTO *(DETAIL)*, NAC C-060798

Skeleton

□ Skeleton is a family *crest* among some groups (for example, the far northern Eyak peoples), which is not surprising considering widespread traditional beliefs regarding the importance of *bone*.

skil

□ A skil, sometimes called a *potlatch* ring, is a cylindrical object that, among the Haida, symbolizes wealth and status. The top of a chief's *hat* or a section of a *totem pole* often has a cylinder marked into a number of skils. The number of segments may indicate the number of potlatches hosted by the wearer of the hat, the owner of the pole or his family.

skull

☐ Skulls indicate associations with cannibal spirits, and also with *ghosts* and ghost dancers. They appear as *masks*, ornaments, or decorative motifs on other objects.

Skulls are a prevalent image in the ceremonial objects and regalia for the *Hamatsa* (Cannibal Dance) of the Kwakwaka'wakw. An initiated Hamatsa dancer may add a carved skull ornament to his dance cape each time he performs.

sky world

(see also cosmos)

☐ The sky world is the home of the *Sun*, *Moon* and stars, as well as mythic birds such as *Thunderbird*, *Huxwhukw*, *Cannibal Raven* and *Crooked-Beak*.

Snag

☐ Snag is sometimes a personification of a piece of driftwood or a deadhead, the seafarer's obstacles.

Among the Haida, Snag is called Ttsaamuus, and he is an alternate form of *Taangghwanlaana*, the One in the Sea. Snag is also intimately associated with *Sea Wolf*, *Sea Bear* and *Beaver*.

Snag may be identified by a long hook extending from the top of the head, or spikes on the shoulder. The face features are generally humanoid. It may be holding a stick to represent driftwood or a deadhead.

Boxes designed to contain treasured artifacts commonly feature Snag, or Snag alternates, as decorative motifs. In Haida sculpture, Snag is frequently counterbalanced by *Raven*, who is a close relation. Snag below and Raven on top is a common arrangement on Haida poles,

recalling the original "house pole": Snag's stone post, located at the bottom of the sea in the time before the world was formed. To wear a Snag motif, for example a *Sea Bear*–decorated robe or blanket, indicates an acceptance of responsibility for supporting the world.

snake

(see also Lightning Snake)

☐ Snakes are found on the Northwest Coast, although no poisonous varieties occur, except for the occasional rattlesnake that has wandered in from the interior. Snakes are uncommon in Northwest Coast Native art. Some sources claim that they were regarded with fear by indigenous peoples, who neither ate them nor hunted them for their skin.

Nuu-chah-nulth lore includes stories about nasty little snakes that like to jump uninvited into human orifices. Talented Salish weavers might have Snake as a spirit guide.

Snot Boy

☐ North of Barkley Sound on Vancouver Island, in Nuu-chah-nulth territory, Snot Boy is the main cultural hero. Like *Raven* in the mythology of northern tribes, Snot Boy causes trouble, makes things happen and changes everything: he is the ultimate *Transformer*.

soulcatcher

☐ Shamanic doctoring includes a great deal of oral symbolism. The *shaman* sucks and blows, affecting movements and displacements of spirit and supernatural power. A patient's soul was most likely to leave its body at dusk, and the shaman might then suck the infected soul into a tubular implement called a soulcatcher,

cleanse the captured soul and return it in a healthy state to the patient. The soulcatcher was often carved in the likeness of powerful beings such as *Sisiyutł* or *Killer Whale*.

Sparrow

☐ In stories, Sparrow is a minor being, a messenger who calls creatures together for meetings and ceremonies. An important group in the *Winter Ceremony* of the Kwakwaka'wakw is called Sparrows; a group of *four* of them serve as messengers and informers.

Sparrow is depicted in the art with a small, pointed beak, often in an open-winged posture of flight.

speaker's staff

(see talking stick)

Spider

☐ The spider does not often feature in the art of the Northwest Coast, although arachnid characters sometimes appear in the myths.

spindle whorl

☐ The spindle whorl is a disk-shaped object with a hole in its centre, through which a thin rod is inserted. This implement is used to spin wool into strands. Often, the spindle whorl is finely carved with images, to invest both the tool and its user with skill and creative power.

Spindle whorl motifs may be recognized by the presence of two concentric circles differing greatly in circumference. The outer circle—representing the spindle whorl's outer edge—usually defines the outer limit of the design, while the inner circle—representing the hole through which the spindle rod passes on the actual implement—is much smaller and draws the eye to the centre of the design.

Today, Salish artists pay homage to their ancestry by including spindle whorl motifs in their work. Susan Point and Manuel Salazar are two contemporary Coast Salish artists whose portfolios reveal a powerful affinity for this symbol.

spirit board

☐ A spirit board is a hinged decorated panel featuring *crest* figures, which serves as a prop during ceremonial performances. For example the board may rise from the floor and grow in height, apparently unaided, to announce or display the crest affiliations of performers.

spirit canoe

☐ A spirit *canoe* transports souls during voyages to realms beyond the earthly. A *shaman*, for example, uses a spirit canoe to travel to the *spirit world* where the dead reside, in order to rescue lost souls or secure important knowledge that will help the living.

In the art, a spirit canoe may appear as an entity partly canoe and partly animal. A canoe image is often fused with the head and body parts of an animal or animals, such as *Sea Lions* or *Land Otters*. The creatures aboard the canoes are spirits, spirit helpers and shamans.

Spirit Whaler

(see Pooq-oobs)

spirit world

(see also cosmos, shaman, spirit canoe)

☐ The spirit world is the realm of the dead,

ghosts and supernatural beings associated with the dead, such as *Bak̲was* and *Gagiid*.

spoon

☐ Feast spoons and ladles play an important part in Northwest Coast cultural traditions, feasting and ceremony. Ladles were generally made of *wood* or the horn of *mountain sheep*, usually with *crests* on the intricately carved handle. The mountain sheep horns were steamed and moulded to form the bowl part of feast spoons, whose long handles of *mountain goat* horn were intricately carved with crest and mythic beings, and sometimes inlaid with *abalone shell*, *opercula* or *copper*. In recent times, miniature spoons of silver or gold have become popular.

squid

☐ The Nuu-chah-nulth have stories about giant squid creatures that dwell in the sea, but apparently did not generally fear them as they did other sea monsters. Squid depictions often show the distinctive tubular body and tentacles.

Squirrel

☐ The squirrel is admired for its agility and resourcefulness, and for its wariness and alertness: its call warns people of approaching danger and enemies. Squirrels are not commonly depicted in the art, although they are sometimes cited by *shamans* as useful spirit helpers.

Nuu-chah-nulth lore teaches that shaman-squirrels may be encountered in the woods, singing and shaking miniature *rattles* over dead, infested logs; such an encounter is an opportunity to gather strong medicine power.

Starfish

☐ Starfish occasionally appear as personified figures in *crest* and story art, and may adorn depictions of other sea creatures. In Kwakwaka'wakw art, *K̲umugwe'*, chief of the *undersea world*, sometimes wears Starfish as a headdress.

Starfish is easily recognized by its shape; its appendages, unlike those of *Octopus*, do not feature round suckers.

Sun

☐ As in all cultures, Sun stands as a symbol of life and creative power. The reverse side of this munificence is its scorching, destructive potential.

Sun appears often in Northwest Coast art and features prominently in myths, often acting as a benevolent spirit guide. Sun is often, but not always, depicted as masculine in nature. Among the Nuu-chah-nulth, Sun and Moon, who are married, represent the highest powers. This is one of the rare instances where Sun is personified as female.

Among the Nuxalk, the supreme being and master of the *sky world* is sometimes called Sun. This is an original, uncreated being, who at the beginning of the world placed *four* supernatural Master Carpenters of varying species on four separate mountaintops to create the world and found the Nuxalk *clans*.

Many Salish considered Day, Daylight, or Sky to be the supreme supernatural entity. Sun could appear to an individual disguised in human or animal form and bestow great spirit power.

Sun is not a very common *crest*, except perhaps among the Kwakwaka'wakw, where it figures in some lineages as an ancestor. One

myth speaks of an illustrious sky-dwelling ancestor who each morning dons a glorious cloak of *abalone shell* and walks across the firmament.

Sometimes Sun is personified as a very elderly man: the Sun costume will show old man Sun dressed for ceremony (that is, ornamented with *copper* or abalone shell), and the dancer playing the part of Sun will walk the stage slowly, as an old man might.

Although the Kwakwa̲ka'wakw regard Sun as an old man, he nonetheless retains his impressive power in myths that honour his creative potency. A single sunbeam is strong enough to impregnate a woman. *Mink*, for example, is a Son of Sunshine.

Some stories recount the time when Sun was young, headstrong and impulsive. As a naughty child, Sun moved so fast and recklessly across the sky that he angered his Auntie Clouds, whose retreat from their guardianship posts resulted in the world receiving terrible burns.

Many myths recall a time when Sun overwhelmed and scorched the earth and its inhabitants. Clever heroes inevitably save the world, bringing relief through the creation of cloud, fog and night.

In Haida myth, Sun was stolen by *Raven*, who took it from an old man who kept it in a box, and subsequently released it to illuminate the world for the general benefit of humankind.

In the art, Sun is characterized by a round face with any number of surrounding rays, or at least the suggestion of rays. The rays may be shown in the shape of hands, which expresses the creative and benevolent nature of Sun. On occasion, artists give the sun the face of a *human*,

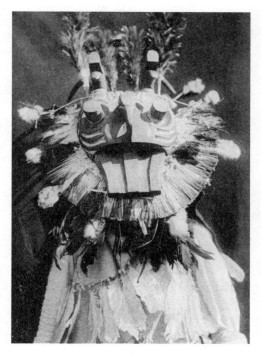

Sxwaixwe mask (Cowichan tribe, Coast Salish). EDWARD S. CURTIS PHOTO *(DETAIL)*, NAC C-034796

Eagle, or *Raven*. Whatever the countenance, Sun depictions tend to exhibit regular, formal, ideal, features, which are generally humanoid except for the beakish, hooked nose. Sun is sometimes associated with *copper* or Coppers, and may feature copper decorative elements.

Supernatural Crane
(see Khenkho)

Swan
(see Goose)

Sxwaixwe
(Swaixwe, Sxwayxwey)
☐ Sxwaixwe is a supernatural lake spirit who has the power to cause earthquakes. It aids

ritual cleansing and is called upon in times of crisis.

Sxwaixwe is a very important, prestigious guardian spirit of certain Coast Salish families. This is the most prominent Salish spirit to be represented with a dancing *mask*: the mask and its dances appear as part of the winter Spirit Quest ceremonies. The full costume features many feathery components and deer hoof ankle-*rattles*.

The Kwakwaka'wakw wanted the right to this mask and its attendant ceremonials. They threatened to make war on the Comox tribe of the Coast Salish, and the Comox people made a peace offering of Sxwaixwe masks, costumes and dances. Thus the spirit, with its image and ceremonies, spread from one culture to another.

A Sxwaixwe mask has distinctive, protruding cylindrical eyes and a hooked, beakish nose. The mouth is often gaping and displays a long tongue. Prominent ears in the shape of bird heads or other animal heads may extend from the top of the forehead. The nose also conventionally features such a head. *Feathers*, sea lion whiskers or long thin shoots adorned with tufts of down protrude from the top of the head. The full costume includes a scallop-shell or wooden rattle, a neck shield, and swan feather clothing. Kwakwaka'wakw versions of the masks, which they call *Xwixwi*, are often more colourful than those of the Salish.

T

Taangghwanlaana

□ In Haida mythology, Taangghwanlaana, the One in the Sea, is grandfather of *Raven* and the powerful chief of the *undersea world* who controls the flow of wealth into the world from his house at the bottom of the ocean. He is an alternate form of *Snag*.

Tal

□ Tal is a supernatural giantess of the Comox people of the Coast Salish nation. She has habits like those of *Dzunuk̲wa*, the Wild Woman of the Woods, for she likes to steal and eat human children. In depictions, Tal has a large, bent, humanoid nose; deeply set eyes; an open mouth; and long hair. The rights to the *mask*, stories and dances may be inherited or purchased.

Talio

(Copper Maker Woman, Tlakwakilayokwa)

□ A Kwakwa̲ka'wakw female spirit and the wife of *K̲umugwe'*, chief of the *undersea world*, Talio was a high-ranking human woman until the supernatural chief of the undersea world abducted and transformed her. Her portrait resembles that of *K̲umugwe'*, and she, like him, is associated with wealth and *Coppers*.

talking stick

(speaker's staff)

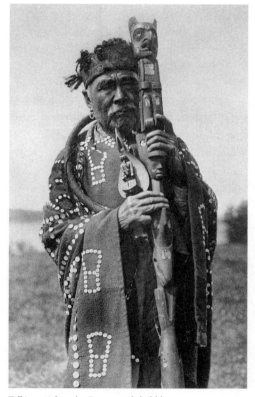

Talking stick and a Raven *rattle* held by a Kwakwa̲ka'wakw man wearing a *button blanket* with a motif of *Coppers*. EDWARD S. CURTIS PHOTO, NAC C-020826

□ The talking stick was held by the speaker, who stood beside the *chief* at ceremonies and announced the chief's wishes. The talking stick was the property of the chief and was intricately carved with his *crests* and family

stories, much like a miniature version of a *totem pole*. Today, at gatherings, it is the turn of whoever is holding the talking stick to speak.

Tanis

(see Hamatsa)

tattoo

(see also jewellery)

□ Facial and body tattooing were practised widely among both sexes. Tattoos representing *clan* and family *crests* were common in some northern societies, while geometric designs were the norm in many southern regions.

Tattooing and ceremonial ear piercing could be done at any age, to individuals of either sex. Among the Haida, a four-day-old infant might undergo piercing (*four* is a particularly significant number). Among many tribes, girls had their lower lip pierced and decorated with a *labret*. All of these modifications of the body served purposes beyond the aesthetic, identifying kinship ties, rank and marriageability.

Thrower of Sickness

(Mitla, Mamaka, Mamaqa)

□ The Thrower of Sickness is a Kwakwa̱ka'wakw *Winalagalis* (War Spirit) dancer, a being with the power to control life and death by "throwing sickness" at people. He wears hemlock neckrings and carries a *Sisiyutł* bow and magic staff, which he can make longer or shorter at will.

Thunder

□ Thunder's mythical origins vary. Many stories describe the cause of thunder, and many powerful supernatural creatures have "thundering" habits. The flapping of the great wings of *Thunderbird*, for example, is one source of thunder. During theatrical performances, the sound of thunder is sometimes imitated by rolling rocks inside a long, large wooden box.

Among the Nuxalk, Thunder is sometimes personified and depicted as an imposing, heavy-featured humanoid being.

Thunderbird

□ Thunderbird is the illustrious ancestor of many prominent human lineages and a proud, powerful and noble being in myths throughout the Northwest Coast.

Thunderbird is a giant, supernatural bird, named for his habit of causing *thunder* and lightning. Beneath his wings he carries *Lightning Snakes*, which are his weapons. *Thunder* rolls from the flap of his wings, and lightning flashes when he blinks his great eyes or throws the Lightning Snakes. He is large and strong enough to hunt *Killer Whale*, which he strikes dead with the wolf-headed, serpent-tongued Lightning Snakes. Thunderbird carries his prey high into the mountains to feed. From his home in these great heights, Thunderbird rules majestically, keeping a close watch over his dominion.

Thunderbird is intelligent and proud, and humans who attempt to outwit Thunderbird are certain to have their intentions backfire. In Nuu-chah-nulth stories, Thunderbird is a giant mountain-dwelling man who dons a bird-like costume when he ventures out to hunt whales. His Lightning Snakes are feathered serpents; people refer to them as Thunderbird's dogs, and their heads are portrayed as dogs or wolves.

Some Coast Salish myths say that Thunder-

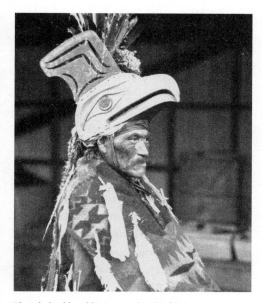

Thunderbird headdress worn by Chief Joseph John (Nuu-chah-nulth), c. 1929. A. V. POLLARD PHOTO (*DETAIL*), NAC PA-140976

quently give Thunderbird a beak that is longer than that of *Eagle*. Thunderbird is often depicted with Killer Whale, who may appear captured in his talons. Pairs of Lightning Snakes may accompany the Nuu-chah-nulth Thunderbird; often these harpoon-like, long-tongued serpents are located underneath the outstretched wings of the great bird.

Tlakwagila
(see Ḵumugwe')

Tlakwakilayokwa
(see Talio)

Tła'sala
(see Dhuẃláx̌a)

Tl:eetsa'apleetlana
(see L'etsa'aplelana)

Tloquana
(see Wolf Dance)

Tokwit
(see Tuxw'id)

totem pole
□ Totem poles, each carved from a single cedar trunk, are among the largest works created by Northwest Coast artists. Traditionally, free-standing totem poles were placed before *houses* to proclaim the identity and status of the owners; some, called housefront poles, stood up against the centre front of houses. These and other types of poles were carved or carved and decorated with *paint* to display the owners' family history, ancestors, *crests* and myths.

Outsiders cannot always interpret the

bird's favourite perch is Black Tusk, a monolithic peak in southern British Columbia. The Quileute people of Washington state, on the other hand, identify the Blue Glacier of Mount Olympus as Thunderbird's favourite haunt and primary residence.

Thunderbird is very important to the Kwakwaka'wakw, who in legendary times made a deal with the powerful bird: in exchange for Thunderbird's aid during a crisis, the Kwakwaka'wakw agreed to honour him for all time by making his image prominent in their art. Thus, a number of their *totem poles* feature Thunderbird perched at the top with his great wings outstretched.

Thunderbird exhibits a powerful hooked beak; prominent, often curly, ears (otherwise known as horns or head appendages, and always symbolic of supernatural power); large legs and talons; and large, outstretched wings. Artists fre-

family history or identify the ancestors but often recognize some of the crests. The saying "low man on the totem" is a misconception, as the bottom figure is not necessarily the least important; often the figures at eye level are the most important. When a pole is raised, the history it tells is publicly declared, along with the *names*, rights and property of the owner.

Other types of carved poles include the houses posts that hold up the beams of the house; mortuary poles that hold the remains of the deceased in a *box* at the top; and *welcome figures*. The carving of poles originated with northern groups, but today they are made by all the coastal groups. Model poles are also carved in *wood* or in *argillite*.

transformation mask
(see also mask)

□ A transformation *mask* is an impressive feat of engineering, with hinged segments designed to open and spread out at the pull of a cord, revealing a second and even third being underneath the first. The transformation mask is an artistic embodiment of the spiritual beliefs of the culture. Some transformation masks are among the largest masks ever produced.

Transformer
(see also Coyote, Mink, Raven, Snot Boy)

□ The Transformer, who is *Raven* in most northern Northwest Coast mythologies, is the being responsible for numerous acts of creation or re-creation, and the cycles of transformation and *reincarnation*. The Transformer is not revered as the supreme being, but is considered to be the active earthly agent of the *Creator*.

The Transformer's nature is intelligent and adventurous, but sometimes self-indulgent, mischievous and contradictory. In some cultures such as the Heiltsuk, he is noble and serious; in others, such as the Haida, Tlingit, Tsimshian and Kwakwaka'wakw, he is both a greedy, bumbling fool and a wise, inspired genius. A wealth of stories relate his endlessly entertaining exploits.

In some Coast Salish groups, Transformer is a serious, industrious individual who bestowed *names* and knowledge on the first ancestors, who dropped out of the sky at certain significant geographic points chosen by the creator. Among other Salish groups, *Coyote* is both Transformer and Trickster. Transformers in Nuu-chah-nulth mythology are *Mink* and *Snot Boy*.

tree
(see also cedar, wood)

□ Tree motifs are often considered to be representative of the cedar. Tree elements may appear as *crest* figures: for example, Bark is a crest among the Tlingit.

Nuxalk mythology features a Cosmic Tree, which may be imagined as a vertical pole or axis connecting the diverse realms of the universe.

In Tlingit mythology, Tree People are a race of human-stealing giants. The Nuu-chah-nulth, likewise, tell stories of elusive Tree Spirits known to kill unwary humans. For these coastal peoples who historically lived at the shore and gathered most of their food from the sea, the dense forests at their backs could be frightening, mysterious places full of dangerous spirits.

The giants of the forest are never far from Northwest Coast consciousness. Images of trees themselves are rare in the traditional art,

but contemporary artists produce pieces that feature tree representations and motifs.

Abstract Tree of Life designs sometimes appear in the art, particularly on *button blankets* and in two-dimensional graphic arts.

One popular contemporary graphic art style fuses traditional figurative, emblematic and formline designs with naturalistic renderings of coastal landscapes. The tree is a central component in such work. This style is a trademark of artists such as Roy Henry Vickers and April White.

Trickster
(see Blue Jay, Coyote, Raven)

T̓seḵa
(Tsetseka, see Winter Ceremony)

Tsonoqua
(see Dzunuḵwa)

Ttsaamus
(see Snag)

turtle
(and **sea turtle**)
□ Turtles did not appear in traditional Northwest Coast art, but some contemporary artists do depict them. One artist explained that he carved a sea turtle out of his deep respect for the long journey the creature sometimes makes to visit the Northwest Coast.

Tuxw'id
(Tokwit, Toogwid, Tuk'wid)
□ Tuxw'id is a Kwakwaḵa'wakw female *warrior* spirit who features prominently in *Winalaga̱lis* (War Spirit) dance ceremonies. The

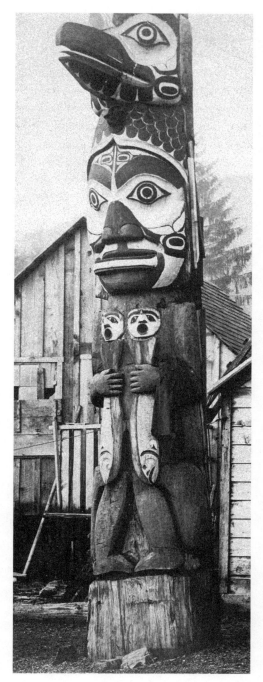

A figure holding Salmon *twins* is featured on this pole, c. 1885. G. BAGNANI COLLECTION *(detail)*, NAC PA-118783

likeness of a bloody, severed human head is used to convey the illusion of her decapitation.

Tuxw'id gains her power from Winalagalis, and is associated with magic, trickery and the power to transcend death. In various manifestations of her legend, she might give birth to a giant frog, make birds appear, or cause the *moon* to rise and set. She demonstrates her invulnerability by demanding to be decapitated, burned, disembowelled, or drowned, so that she might return, whole but scarred, to dance her triumph.

During the Winalagalis dance, Tuxw'id may conjure up *Sisiyutł*, who appears from the ground in the form of growing *power boards*, while *Crabs* (in the form of puppets) scuttle across the floor.

twins

☐ Twins are widely associated with *Salmon*. In some regions, all twins are rightful owners of Salmon *crests*. The Nuxalk once believed that twins were conceived when a Salmon magically entered the body. Nuxalk twins and their families could cause the salmon runs to start by throwing offerings of miniature salmon carvings into the water.

Alternately, the birth of twins could bring great misfortune to individuals and communities if strict taboos, such as long periods of isolation for the babies and their parents, were not observed. Twins are magical, and people must be careful and conscientious in handling them: twin power may be harmful or beneficial.

U

undersea world

(see also cosmos, ocean)

☐ The undersea world is ruled by a chief called K̲umugwe' (meaning "Rich One") by the Kwakwa̲ka'wakw and called Taanggh-wanlaana (the One in the Sea) by the Haida. He commands sea creatures such as *Whales*, *Seals* and fish. The undersea world is home to both dangerous sea monsters and harmless beings.

V

Volcano Woman
(Woman-of-Fire)

☐ Volcano Woman is often associated with *Frog*, who serves as her familiar and is her most precious ward. People must respect Volcano Woman and her charges; she protects wild creatures as her children. Her nature is potentially volatile, vengeful and violent. In one Haida story, the wanton killing of a frog leads her to destroy an entire village. She controls the activity of mighty volcanoes and acts remorselessly in defence of her beloved wild creatures.

W

walrus

□ Although the walrus is a denizen of the Arctic, Northwest Coast peoples sometimes acquired walrus tusks in trade via northern inland groups from the Inuit. *Shamans* used walrus tusks as powerful charms or amulets, whether carved or uncarved.

War Spirit

(see Winalagalis)

warrior

(see also Tuxw'id, Winalagalis)

□ Traditionally, Northwest Coast societies were competitive and proud, celebrating war, valour and ferocity. Much of their art and mythology reflected these values.

The elaborate dance ceremonies performed to initiate young candidates into the fold may have evolved from the rituals of ancient warrior societies.

People may use warrior images to tell stories of successful campaigns and heroic deeds. Warrior art and storytelling may serve to bolster the reputation of individual fighters, *shamans*, *chiefs*, or entire tribes.

The Kwakwaka'wakw War Dancers used to play a prominent part in the *Winter Ceremony*. They would demonstrate their invulnerability by publicly undergoing skin piercing, after which they would be lifted off the ground by their pierced skin. They were adorned with images of *Sisiyutł* , the double-headed serpent with many powers that is a spirit helper of warriors. Similarly, certain Nuu-chah-nulth *Wolf Dance* participants used to allow themselves to be skewered in ritual performances.

In artistic depictions, a warrior often appears with bleeding wounds on the forehead and cheeks. Some are shown decapitated, but these are generally heroes who, fortunately, know secret ways to renew life.

Wasco

(Waasghu, Wasgo; see Sea Wolf)

Wasp

□ Wasp is a rare figure in Northwest Coast art and mythology. In one Kwakwaka'wakw story, Wasp has the power to kill *Thunderbird*. Wasp, like *Bee*, sometimes appears as a comic character in interludes of ceremonies. Depictions of Wasp feature a short, square, face; round eyes; a protruding stinger; and, often, a malevolent expression.

Watchman

□ The Watchman is a human guardian figure who is responsible for protecting his owner's property, and in some cases an entire village

or region. Watchmen are not generally a family *crest*, although they may be very important to their owners.

In Haida art, Watchmen often grace the tops of *totem poles*, singly or in groups of two or three, wearing conical *hats* topped with *skils* indicative of their power and high status. Watchmen also occasionally appear in Tsimshian and Tlingit art. Their presence generally indicates northern tribal associations.

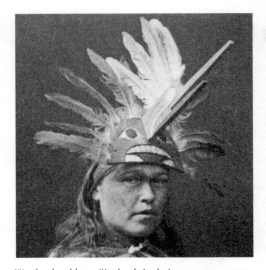

Weather headdress (Kwakwaka'wakw). EDWARD S. CURTIS PHOTO *(DETAIL)*, NAC C-079006

weapon

□ Various traditional weapons may be depicted in the art: spear, *harpoon*, bow and arrow, snare, knife, sling and dart, club. The blades of weapons were made of bone, teeth, antler, shell, slate or copper, and later of iron.

After contact with Europeans, guns became very popular and were coveted trade items. Wealthy chiefs amassed large gun collections, despite the significant decline in warfare and violent conflict. The guns might never be put to use, except as symbols representing the proud owner's superior wealth and status.

Weasel

□ Weasel-like creatures such as the *marten*, fisher and ermine are found almost everywhere on the Northwest Coast; *mink* are found everywhere but Haida Gwaii. These figures are infrequent in the art, and it is easy to mistakenly identify *Otter*, a more common subject, as Weasel. *Land Otter*, in particular, appears in shamanic art.

The Weasel Dance is another name for the Peace Dance of the Kwakwaka'wakw, during which an initiate disappears and returns transformed into a *crest* being. Perhaps the ceremony is referred to as the Weasel Dance because

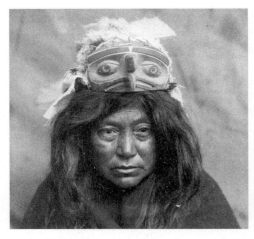

Weather headdress (Kwakwaka'wakw). EDWARD S CURTIS PHOTO *(DETAIL)*, NAC PA-120425

the initiate first appears to the audience in a costume that includes many ermine pelts trailing from his headdress.

Weather

(see also under separate names)

□ Anthropomorphic depictions of weather—

and aspects of the land—are common in the art and mythology, reflecting the core belief that all things, whether animate or inanimate, have a spirit.

Entities with human or animal characteristics may represent such natural phenomena and land features as *thunder*, air, wind, clouds, lightning, water, rocks, *mountains*, glaciers, *earthquakes*, etc. Among the Nuxalk, the *Sisaok* dance ceremony, and all of its attendant stories, songs, costumes and props, feature such environmental personifications.

Depictions of weather and geography are diverse in appearance and are sometimes difficult to identify.

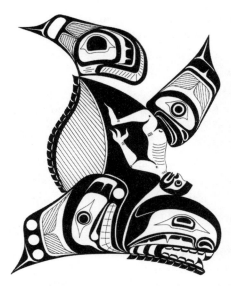

Kwakiutl Killer Whale, print by Richard Hunt (Kwakwa̱ka̱'wakw): Killer Whale, Human, Eagle.

welcome figure

☐ Some traditional freestanding Coast Salish poles and exterior house posts depicting a single human, occasionally with arms extended, at the entrance to a community or dwelling, may be intended as a sign of welcome.

whales and whaling
(see also Baleen Whale, Blackfish, harpoon, Killer Whale)

☐ The killer whale or orca is by far the most prevalent whale species in Northwest Coast art and mythology. Baleen whales (usually gray or humpback) are quite common, especially in Nuu-chah-nulth art. Other whale species that live in or pass through the region but are rarely depicted include pilot (or *blackfish*, which, confusingly, was also once another name for the killer whale), fin, sei, minke, blue, sperm and northern right.

Native whalers traditionally hunted mainly humpback and California gray whales. The Nuu-chah-nulth and the Makah were partic-ularly prominent whaling cultures in bygone days. Whaling was considered a prestigious, noble and dangerous undertaking.

Numerous *masks*, effigies and other items were designed to bless chief whalers and their crews. Today, whale figures are still a major subject among Northwest Coast artists.

whistle

☐ Carved and decorated wooden whistles were sounded to announce the presence of supernatural beings to mark the beginning of the *Winter Ceremony* season or to announce particular portions of ceremonies. Some were secretly blown. There were many kinds of whistles with particular sounds or notes that had special meanings.

Wild Man of the Woods
(see Ba̱k̲wa̱s, Gagiid, Land Otter, Pk̲vs, Pooq-oobs)

Wild Woman of the Woods
(see Dzunuk̲wa, Property Woman, Tal)

Wihalait
(Great Dancer)
□ Among the Tsimshian, a *chief* in full cere-
monial regalia may embody the role of
Wihalait (Great Dancer). The chief in this
role holds *rattles* and wears an elaborate head-
dress, a *Chilkat blanket* and leggings, a painted
or ornamented dance apron, and large bark
neckrings.

Winalagalis
(Mitla, War Spirit, Warrior-of-the-World)
□ In Kwakw̲aka'wakw mythology, Winalag-
alis is the spirit guide and shamanic healer of
Baxwbakwalanuxwsiwe' himself. He is a tall,
thin, black, small-headed man with bat-like
eyes who travels in an invisible *spirit canoe.*
Winalagalis is also the name of a dance cere-
mony. Among the Heiltsuk, both the mythic
being and the dance ceremony are called
Mitla.

Winter Ceremony
(Red Cedar Bark Dance, T̓sek̲a, Tsetseka)
□ The nations of the Northwest Coast held
their dance ceremonies in the winter months,
when supernatural beings were said to visit
human settlements. By then, the bulk of the
annual food harvest was in, and people could
devote long hours to the performance of rit-
uals and the production of regalia, elaborate
entertainments and feasts.

The main purpose of the Winter Cere-
mony was to initiate novices in rituals such
as the *Hamatsa* (Cannibal Dance) of the
Kwakw̲aka'wakw.

Today, conventions are evolving to meet
the needs of a modern community. Cere-
monies are shorter and may be scheduled in
the summer, when travel is easier.

witch
□ The witch is an evildoer, arch enemy and
alter ego of the *shaman*, whose job it is to
detect witches and cure or punish them,
sometimes by torture resulting in death.

A witch may be male or female and has
extraordinary powers, similar to those of a
shaman, but used in the service of evil. Both
witch and shaman are intimate with other
realms—physical and metaphysical—beyond
the safe and known world of daily human
activity.

A witch might obtain power from human
bones or dead dogs. The victim's personal
effects and body parts may be used to effect
harm through sorcery, using various forms of
sympathetic magic. A doll representing the
victim could be placed next to the corpse of
a dog, for example, in a witch's attempt to
cause sickness or death.

A curse might be reversed if a shaman
forced the witch to remove the doll and wash
it in the ocean. The ocean cleanses evil, so
witches were sometimes tied up and left on
the beach to drown in the rising tide. Objects
associated with witches and witchcraft are
sometimes called witch's dirt.

Depictions of witches are relatively un-
common in the art, perhaps because artists
wish to encourage the triumph of good by
focussing on the shaman, and those spirits,
even those frightening and sometimes mali-
cious ones, whose power may be harnessed
for good.

Among the Tlingit, depictions of witches are traditionally found on *Oystercatcher* rattles, and occasionally on *argillite* or *wood* carvings, often made for sale to non-Natives. A bound witch indicates shamanic associations. Shamans are sometimes shown holding witches, by their long hair, in positions of subjugation.

Wolf

☐ Wolves traditionally inhabit all regions of the Northwest Coast except for Haida Gwaii, where their physical absence may contribute to a relatively low profile in the art. In populous southern regions, wolves are now extremely rare, if not entirely absent.

People respect the wolf for its strength, agility, intelligence and capacity for devotion. The wolf's vocal range and communicative powers are impressive, and Northwest Coast peoples traditionally believe in the potency and magic of speech and song. Wolf is sometimes an agent of *transformation*, and is a popular figure in *crest*, story and shamanic art.

In some legends, four Wolf cubs survived the great *flood* by climbing to the peak of a high mountain. After the waters receded, they howled loudly to find out if any other survivors existed. Humans heard the cries, and the young wolves entered the human community. Other myths and legends recount similar tales of adoption by Wolves and of Wolves. Wolf Mother is sometimes depicted with a human child.

Wolf is a principal *crest* of many prominent Northwest Coast families. Among the Tlingit, Wolf is an alternative to *Eagle* as the crest of one of the two main *clans*. Among most Tsimshian groups, Wolf is one of four main clans. Wolf Den and even Wolf Bath

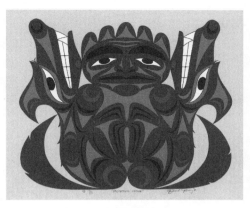

Protecting Mother, print by Maynard Johnny Jr. (Coast Salish): split Wolf, Human in centre.

Wolf mask (Kwakwa̱ka'wakw). EDWARD S. CURTIS PHOTO (DETAIL), NAC C-030915

House appear as crests among far northern clans.

In some regions, Wolf is credited with teaching men the secrets of whaling. In all regions, Wolf serves as an inspiration and a charm for hunters and fishers, and skilled hunters often have Wolf spirit guides. *Warrior* societies and their ceremonies may exhibit Wolf as a central participant.

In some legends, the first *Killer Whale* is said to have appeared when a Supernatural White Wolf entered the sea and transformed.

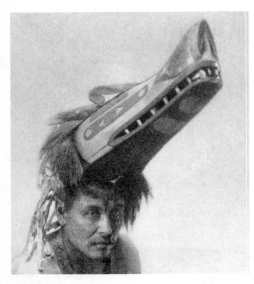

Wolf mask (Kwakwaka'wakw). EDWARD S. CURTIS PHOTO
(DETAIL), NAC C-034795

Wolf and Killer Whale are known as intimate relations, exhibiting similar colourings, similar pack behaviours and similar skill in hunting. Many legends describe Wolf's ability to transform into Killer Whale, and vice versa.

Wolf is usually identified by a long snout with nostrils; long, sharp teeth with prominent fangs; tall, narrow ears; ovoid eyes; clawed feet; and a long, curled and/or bushy tail. Wolf may feature an extended tongue, which often curls upward. Wolf representations often feature Killer Whale motifs, a convention that indicates either a *Sea Wolf* depiction, or—if the figure is fully Wolf—the significant relationship that exists between these two creatures.

Wolf Dance
(Tloquana)
☐ The Wolf Dance is an important *Winter Ceremony* of the Nuu-chah-nulth. Initiates are kidnapped by a Wolf Spirit or Super-

natural Wolves, and upon their return they are tamed, purified, reintroduced into society, and required to display the dances, songs and stories that are gifts from Wolf; these valuable heirlooms are protected and passed down for future use.

The Kwakwaka'wakw also have a Wolf Dance that is part of their Winter Ceremony.

Wolverine
☐ Wolverines are found on the Northwest Coast, although they do not inhabit Haida Gwaii (Queen Charlotte Islands). Artists rarely depict these feisty, volatile creatures, although they may appear in stories.

Woman-of-Fire
(see Volcano Woman)

wood
(see also arbutus, cedar)
☐ Of the many materials used by Northwest Coast artists, wood reigns supreme. Important conifers include *cedar*, spruce, Douglas fir and hemlock. The choice of wood is sometimes determined by tradition, as some types of wood have symbolic significance. Various woods have qualities suitable for particular applications. The artist must also know which part of a tree to choose. The wood from a branch, for instance, is much, much harder and denser than the heartwood from the core of the trunk.

Large works, such as monumental *totem poles* and *canoes*, are generally cedar, because these trees grow very tall and straight, and also resist decay. Cedar also has a straight grain that makes the wood easy to split—perfect for making planks for *houses* and *boxes*.

Dishes are often alder wood, which is soft

and easy to work, while *spoons* and implements might be maple, which is a hardwood. Yew, being hard yet flexible, is desirable for bows and clubs.

Woodpecker

☐ A few species of woodpecker such as the northern flicker and pileated woodpecker are native to the Northwest Coast, and occasionally appear in the art and mythology. A talented woodworker might have a Woodpecker spirit guide. Woodpecker is thought to be able to penetrate beyond surfaces to the core of a matter. Depictions generally feature a strong beak and pecked-wood motifs.

Woodworm

☐ Woodworm is a *crest*, but also occasionally appears in shamanic contexts, perhaps because of its ability to bore through wood. Woodworm is said to have powers of perception far beyond the ordinary. Its vision and insight make the creature a useful spirit guide. Woodworm also has the supernatural ability to grow in size and transform into other creatures. The fearsome double-headed serpent *Sisiyutł* sometimes transforms into a giant woodworm.

Woodworm representations have snub-nosed, benign faces with long, round, segmented bodies and sucker-like mouths. Woodworm motifs may appear as eyebrows.

Worm

☐ Along with Woodworm, various wriggling worm-like creatures of the earth and sea may be depicted in the art. The common term "worm" may refer to any armless, legless, finless, tubular creature, and such a creature will often be depicted with a long round body and a round, sucking mouth.

Wren

☐ Wren is a nervous, active, wise, communicative creature who, like *Mouse Woman*, secures and transfers important tidbits of information. Wren also may act as an agent of *transformation*. It is not common in the arts, but plays a key, if minor, role in myths and legends.

X

Xaalajaat
(see Copper Woman)

X̱wix̱wi
(Kwekwe; see also Sxwaixwe)
☐ The Kwakwa̱ka̱'wakw pronunciation of the dance and mask that the Coast Salish call *Sxwaixwe*.

Y

Yagem

(see Iakim)

'Yagis

(T'segis, Tsee'akisa)

□ 'Yagis is one of many Kwakwaka'wakw sea monsters capable of causing storms, waves and dangerous whirlpools. The *mask* of 'Yagis is danced as part of the *Winter Ceremony*. The face is humanoid, with widely set apart eyes, large lips and round nostrils. It is painted with marine motifs and decorated with *copper*, in reference to its association to the *undersea world* of wealth and treasure.

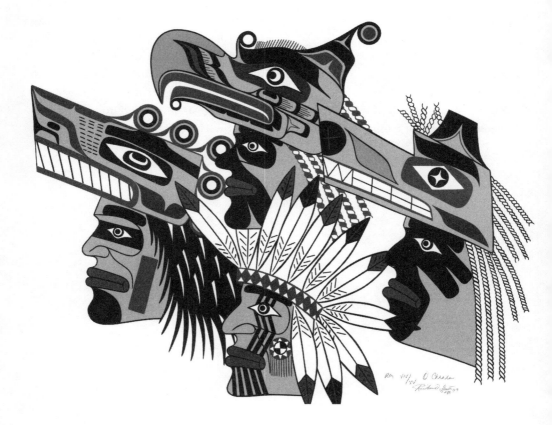

O Canada, print by Richard Hunt (Kwakwa̱ka̱'wakw): *(clockwise from far left)* Nuu-chah-nulth Wolf headdress, Kwagulth Thunderbird headdress, Coast Salish Wolf headdress, Kootenay war bonnet.

The Basics of Northwest Coast Art

Design Conventions

Blue Moon, print by Maynard Johnny Jr. (Coast Salish): the Moon's face shows personification.

Anthropomorphism and personification

Many entities are depicted with human features, including animals, mythic and supernatural beings, and the spirits of inanimate objects and ideas. Likewise, humans may appear with features that are somewhat, or almost entirely, non-human.

Devouring and biting figures

The symbolism of devouring and biting figures is complex and often ambiguous. Such figures may suggest the power to vanquish or consume rivals and enemies. Or, a figure protectively holding another creature in its mouth may be a symbol of guardianship and devotion.

Violent images of wild creatures eating other creatures (particularly humans) may signify

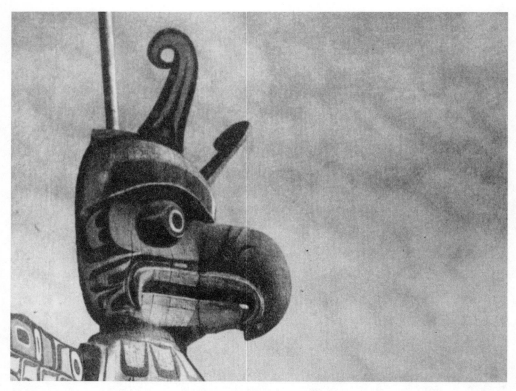

Curly "ears" or "horns" on the head of a Thunderbird (Kwakwa̱ka̱'wakw). EDWARD S. CURTIS PHOTO *(DETAIL)*, C-016786

death, rebirth, *transformation* or communion. Along with *tongue* linking and thrusting, the biting and devouring figures are perhaps the most suggestive sexual aspects of the art.

Double-headed figures

Some beings are double-headed: *Sisiyuⱡ*, for example, always has two wolfish, serpent-tongued heads (and even has a third, a human-like face, in the middle of its body). But many apparently double-headed creatures are actually *split-image designs*, wherein one figure is cleaved in half and splayed to produce two symmetrical, diametrically opposed figures. These may indicate a dual nature.

Alternately, a figure with two different heads may represent a fusion of two or more creatures, symbolizing communion and relationship or a dual nature. Such a design may also be a purely visual, aesthetic choice with no intentional symbolic significance.

Expansive designs

Artists often adapt compositions to fit a chosen shape or space. This is a very old convention in Northwest Coast Native art. Figures may be abstracted to fill the space, sometimes until the

representation is recognizable only by key elements, or, occasionally, until it is no longer recognizable at all.

Traditionally, this practice allowed artists to accommodate designs to the shape of any functional object. In contemporary art, the practice is common even in purely ornamental and two-dimensional graphic art, where the artist has relative freedom of choice in determining the shape and space of the work.

Rayed hair, horns and curly ears

Substantial protuberances on the top of a head generally indicate supernatural abilities or shamanic connections. Such protuberances include imagery of rayed hair, exaggerated ears, curly ear-like appendages, horns and crowns. *Thunderbird*, for example, features tall and generally curly "ears" or "horns."

A crown worn by a *shaman* might be made of bear claws, *mountain goat* horns, or carved wooden pieces in the shape of claws or horns. Spirit guide motifs may be carved at the base of the protuberances. Horns are potent medicine, having the power to draw out sickness when removed from a shaman's head and touched to the body of a patient. Some ancient *petroglyphs* and pictographs show rays or extensions from the tops of the heads of figures.

Skeletal motifs

Skeletal, or X-ray, imagery traditionally indicates shamanic associations. All over the world, in fact, art associated with *shamans* features skeletal motifs and *bones* have special significance: as they are the most enduring part of the body, people believe that bones are a source of life, that animals may be reborn from their bones, and that animal powers may be gained through bone fetishes.

Skeletal elements on regalia may indicate that the wearer has experienced death and resurrection, and thus lives at least partly in the supernatural realm. A shaman in a trance is often able to see through to the bones of living things. Part of a shaman's training involves learning how to mentally divest himself or herself of all encumbrances of flesh and blood, aside from the skeletal. Thus reduced to the essential, the shaman has access to realms of supernatural knowledge and superhuman power.

Split-image designs

Artists often employ techniques of bilateral symmetry. Images may be split down a central axis, and two identical or near-identical figures splayed outwards from this axis. The axis of a split figure may be along the creature's front (in which case the mirror images will face each other), or back (in which case the images face away from one another). Sometimes, the figure's face and head are shown in a single, frontal view, but the body is split and appears as two symmetrical halves extending from the sides of the head. Alternately, mirror images may face opposite directions, meeting ("stacked") along a horizontal axis.

The unfolding of a figure may occur along any axis that the artist chooses: this is a tradi-

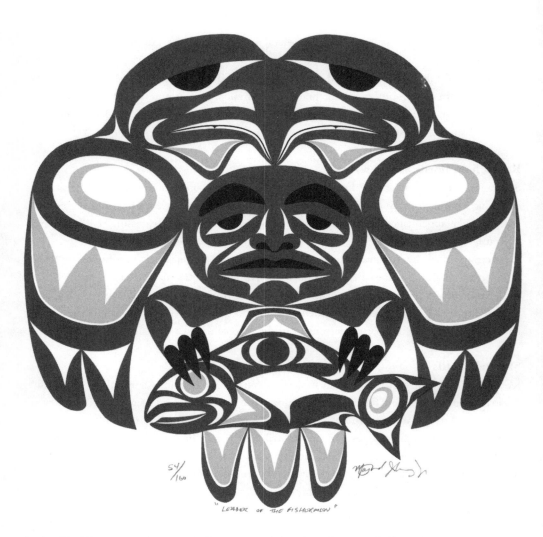

Leader of the Fishermen, print by Maynard Johnny (Coast Salish): split Eagle, Human holding Salmon.

tional convention in which artists frequently display innovation. The origins of this convention may lie in the experience of skinning animals and splaying their hides.

Western traditions and conventions of design promote techniques of perspective, fore-shortening and "realistic" proportioning, whereas Northwest Coast Native traditions use the techniques of expansion, augmentation and splitting.

Tongue thrusting and linking

Tongues are seats of power, life force, and knowledge; they contain great power and magic. They carry messages from other worlds. Transfers of power occur through tongues. Tongue

imagery may symbolize *transformation*, shared knowledge and power, and the ability to speak with creatures of different species.

An out-thrust or extended tongue on a single creature may indicate a display or an abundance of power, and the capacity for transformation or *reincarnation*. A *crest* being with an out-thrust tongue—*Bear*, for instance, often displays an impressive one—is likely indicating great strength and power. However, a protruding tongue, particularly when coupled with a slack jaw, often indicates approaching *death* or the state of trance associated with shamanism.

Symbolically, beings transfer power through offering their tongues to other beings. Linked tongues convey the idea of a universe where all things are essentially interconnected.

In some cultures, a *shaman* carries (or hides) a piece of tongue from an animal that has offered itself to him or her as a spirit guide. Animal helping spirits confer certain powers on the shaman, including the right to use certain songs, and the tongue symbolizes the transference of such rights and powers.

Transformation (combination, fusion)

Transformation is one of the major themes of Northwest Coast art and mythology. Beings have the ability to change from one form to another, and the most powerful *Transformers* can also force such changes on other beings and objects.

In the early myth time, creatures were essentially alike but donned the cloaks of various animals to adopt different appearances and behaviours. Transformation is often described as dressing in the skin of another creature. Many natural and supernatural beings, unlike most humans, are considered to have retained these transformative powers. This belief in the original oneness of all things, and the fallen nature of humankind, frequently surfaces in Northwest Coast art and culture.

Human heroes make journeys to other realms, where they are treated as honoured guests and given wealth and knowledge to carry back home with them. These visits may last for weeks or years in real time, but seem to last only days in myth time. The transformed hero inevitably founds a new lineage and inspires a wealth of legends.

People who foolishly, helplessly or ignorantly accept the food of or heed the call to follow monsters and supernatural creatures, are generally lost to the human world and doomed to inhabit spirit villages, where they gradually transform into monsters themselves.

People often connect violent shifts and changes in weather with corresponding mythic and legendary transformation tales.

A figure sitting or standing on the back of another figure often suggests supernatural movement and travel, which implies the power to transform and the ability to transcend *death* through rebirth.

Beings may be depicted in any stage of transformation. Humans may be shown with elongating noses, feathers, fins, fur or animal-like paws to express metamorphosis, or an otherwise intimate connection with the spirit of the animal represented.

Likewise, non–human creatures may have human hands, or a land mammal may have a whale tail or a dorsal fin, to suggest supernatural essence, extraordinary shape-shifting powers, or a link to a different realm.

In Haida art, a hooked or beakish nose traditionally signals a being, not necessarily a bird, which experiences transformation and metamorphosis.

In the art, transformation may be indicated by displaying the attributes of two or more beings, or by movable or interchangeable pieces. More spectacularly, the state may be shown in a *transformation mask*, which is made to split open to reveal the mask of another being.

Design Elements

Northwest Coast art and design is far from homogenous in style: works range from a close realism to nearly complete abstraction. But the northern style, for which the region is best known, includes a wide variety of formline painting, relief carving and sculpture adhering to traditional formulas. Works are constructed from a small number of recurring, "recombinable" and somewhat "reinventable" elements. These recurring formal elements, in isolation, are highly stylized body parts, which are put together to form a figure.

In the 1960s, Bill Holm attempted to decode the language of Northwest Coast design. He coined various terms to describe the elements of the art; his book on the subject, *Northwest Coast Indian Art: An Analysis of Form*, remains the standard text.

Just as knowledge of the alphabet does not always enable the reader to understand the meaning of a sentence or a story, so knowledge of the design elements alone does not enable the viewer to understand a particular image or the story it tells. Moreover, a single feature such as a blowhole might suggest the presence of either a Killer Whale or a Whale spirit. Traditional knowledge and teachings which allow an individual to decipher the language of Northwest Coast design are not entirely intact—in many cases the old knowledge is simply lost—but contemporary efforts exist towards wider education, or re-education, in this language of design.

Formline

Formline refers to both the Northwest Coast two-dimensional design style and the design elements. In other words, most northern style artworks are examples of formline design, largely consisting of formline shapes. Formlines are contoured lines that vary in thickness and are rarely the same thickness for any distance. Formlines define the whole as well as elements such as body parts. Formlines vary greatly in width and length, and often flow into or conjoin neighbouring formlines to give impressions of relationship and continuity between various elements of the design.

Ovoid

An ovoid is a rounded rectangular shape that is another primary design element. The basic shape is frequently expanded, elongated, compacted or otherwise adapted to fit a variety of

Examples of ovoid design elements (from *Killer Whale*, print by Jeff Greene, on page 62).

contexts and purposes. An ovoid may be solid, or filled with smaller ovoids and/or various other design elements. Ovoids commonly appear as eye sockets and eyes, heads, joints and space fills. The ovoid shape is widely used but is most prominent in the art of northern and Kwakw<u>a</u>ka'wakw groups.

U Form
The U form is a design element that resembles the shape of the letter U. U forms appear in a variety of sizes and shapes, and may define secondary characteristics, serve as decorative filler or help to form the primary body of the image. U forms are also often employed to depict feathers, fins and ears.

Split U
The split U is a variation of the U form that is often used to create feather, tail, fin and ear motifs. The size and proportions of the split U vary greatly, but the distinguishing feature is the presence of dividing lines and/or shading within a U form.

Salmon-trout's-head
Salmon-trout's-head is the name given to a design element especially popular in northern cultures. It is an image featuring fish head elements in profile, enclosed in a round or nearly round outline. The name salmon-trout's-head does not refer to any particular existing salmon species.

This fin detail (from *Killer Whale*, print by Jeff Greene, on page 62) shows some design elements, *left to right:* U form, inside which is a split U; large U form, inside which are two split U forms; and ovoids.

Examples of salmon-trout's head design element (from *Haida Box*, print by Jeff Greene, on page 74).

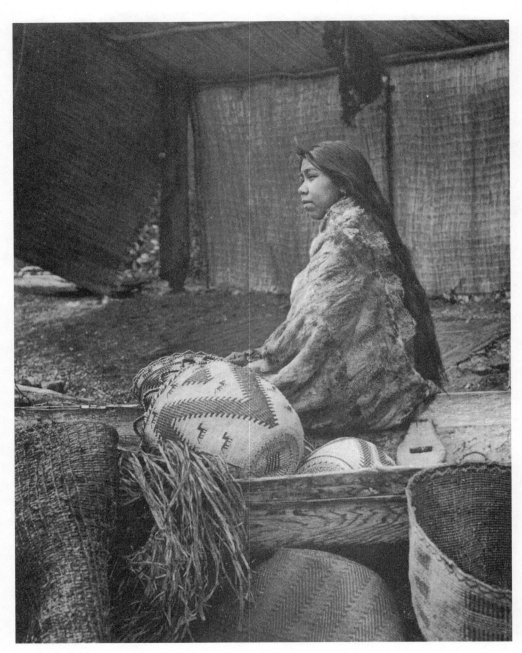

Coast Salish *baskets* and woven bark matting surround a woman. EDWARD S. CURTIS PHOTO, NAC C-026049

Cultural Groups and Art Styles

The names of Northwest Coast cultural groups follow the regional dominance of traditional language families. These various languages are different from one another but have common linguistic features. There are more than forty-five distinct languages within thirteen language families. The brief discussion of cultural art styles below follows, to some degree, the conventional practice of simplification by loosely grouping diverse populations under a much smaller number of linguistic family banners. In a discussion of regional styles, it is practical to simplify even further by grouping a number of distinct northern cultures under one heading, for the work of these cultures displays many similarities.

Coast Salish, including Quileute and Quinault

The Coast Salish nation is the most heterogenous of Northwest Coast Native cultures. Although the Salish generally share a common language family, many of the dialects are mutually unintelligible and tribal cultures may vary greatly from region to region.

Coast Salish art is traditionally more minimal in style than the art of northern tribes. Faces tend to be ovals with a minimum of distinguishing features, and those features are typically smallish, regular and relatively flat. Eyes, noses and mouths, for example, are generally small and relatively expressionless.

If designs are used to fill space in historic Coast Salish pieces, such designs are most often simple and geometric. Coast Salish weavings, for example, follow this convention. Contemporary Salish artists have adapted the old styles and are also developing more dynamic, complex and expressive forms.

Although the Salish were not originally a *totem-pole* producing group, many artists today are nonetheless carving monumental *crest* and story poles.

Salish poles and other objects tended, historically, to represent single figures. Larger traditional Salish carvings include house posts and mortuary posts. In some regions, crests were inherited privileges, while in other regions a person might purchase or dream the right to display certain crests. Apparently, Interior Salish house post figures frequently represent the guardian spirit of the man dwelling in that portion of the house. Today, the traditional freestanding Salish poles and exterior house posts are sometimes called welcome poles or *welcome figures*.

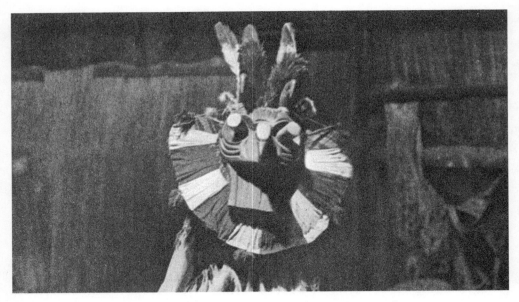

Sxwaixwe mask (Cowichan tribe, Coast Salish). EDWARD S. CURTIS PHOTO *(DETAIL)*, NAC C-020825

Rules were generally less strict among the Salish than in northern regions. Elaborate crest systems such as those of northern tribes were not a prominent feature of the culture.

Some Salish beings include Fisher, *Otter, Mink, Sea Lion, Seal, Bear, Wolf, Killer Whale* and various birds. Salish objects featuring both human and non-human creatures tend to present the human as the larger and dominant motif, in contrast to the stylistic conventions of many other regions. Centred human faces sometimes radiate rays of fish or nestle among surrounding bird figures.

The primary *mask* produced by Salish artists in earlier times features an image of a spirit known as *Sxwaixwe*. These masks are also made by the Kwakw<u>aka</u>'wakw, who call them <u>X</u>wi<u>x</u>wi.

Archaeologists have discovered a variety of stone, bone and antler sculptures, along with decorated beads and implements (some of them copper), at Salishan sites. These artifacts exhibit prominent eyes and representations of creatures such as *snakes*, sea monsters, *herons* and *humans*.

Practical implements and tools, such as *spindle whorls*, were frequently decorated with shallow-relief carving, a practice that is supposed to enhance their power. As a tribute to this tradition, many Salish graphic artists today incorporate "spindle whorl" motifs in their two- and three-dimensional works.

Salish *basketry*, mostly utilizing red cedar bark and roots, is varied, distinctive and impressive. Techniques include checkerwork, coiling, splint-and-lattice, openwork and imbrication. The women were also once renowned for their woven rugs and *Salish blankets*, made primarily from mountain goat and dog wool. The world-famous Cowichan sweaters and hats are a contem-

porary Salish craft. This clothing is European in form and knitting technology but features traditional Salish basketry designs and motifs.

The Salish historically had fewer elaborate ceremonies and fewer ceremonial objects than their northern neighbours. Their Spirit Dance was a very prominent custom, but many versions of it do not use masks and costumes. Some groups, such as the Comox, developed Kwakwaka'wakw-influenced ceremonies and decoration, and therefore produced more of what we now call "art."

Nuu-chah-nulth (formerly Nootka, Westcoast), including Makah

The Nuu-chah-nulth (meaning "all along the mountains") of Vancouver Island and the Makah are traditionally speakers of either the Nootka or the Nitinaht language. The Quileute are culturally but not linguistically related to them. The relative isolation of their coastal communities led to the development of a variety of rich cultures which are, historically, different in many ways both from one another and from others on the Northwest Coast. Significant Kwakwaka'wakw influence is evident in certain objects and ceremonies.

Nuu-chah-nulth *masks* have a very distinctive style, which emerged around the middle of the nineteenth century, featuring two symmetrical halves of the head converging at a sharp angle on a vertical line up the centre of the face. Large eyes follow the plane of the face; eyelids tend to be long with pointed ends, and orbs are small or non-existent; and eyebrows often protrude.

Decorative motifs tend to be geometric, featuring straight and squared linear designs. The split U (often employed as a feather motif) is also a prominent element. Bill Holm has described the contemporary Nuu-chah-nulth style as "prismatic": planes are sharply defined, with surfaces intersecting at angles, and motifs, designs and patterns are linear, geometric and often asymmetrical. Older artifacts display greater naturalism and simplicity of design.

Traditionally, artists produced masks and ritual paraphernalia but few monumental poles or larger works. Many everyday objects, however, bore *crests*.

Kwakwaka'wakw-influenced *totem poles* began to be made late in the nineteenth century. Previously, monumental carvings had consisted primarily of house posts, grave markers and whaling effigies.

Nuu-chah-nulth artists embraced the introduction of foreign pigment and *paint*, and contemporary work continues to favour the application of a wide range of colours.

The *basketry* generally features a tight weave and a variety of decorative, colourful motifs, which are abstracted, geometric representations of humans, animals and objects. Decorations often depict whaling stories.

Whaling, traditionally, was a supremely important activity for the Nuu-chah-nulth. Much art, ritual, ceremony and storytelling evolved around the whale hunt, and the *whale* endures as a common motif. Large mural-sized painted panels commonly feature *Thunderbird*, the supreme whaler, with his favourite prey, *Killer Whale*.

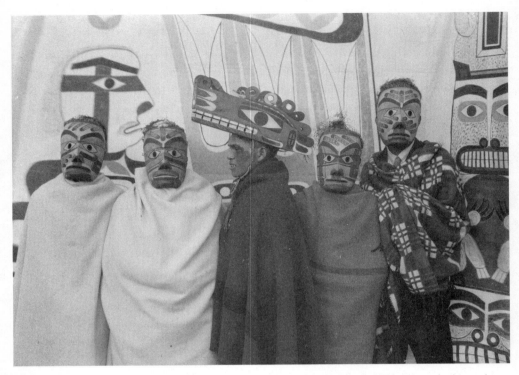

Nuu-chah-nulth dancers, c. 1935: *Wolf* headdress *(centre)* flanked by humanoid masks, *dance screen* in background.
A. V. POLLARD PHOTO *(DETAIL)*, NAC C-089140

Wolf is also a prominent motif in the art and mythology. Wolves are great hunters, who in ancient times gave whaling secrets to fortunate men. The guidance, wisdom and blessings of Wolves are still sought.

Kwakwaka'wakw (formerly and including Kwaguhl, Kwagulth, Kwakiutl)

The Kwakwala language is spoken by a number of associated tribes, many of whom today prefer to be called Kwakwaka'wakw, which is the name for their people in their own tongue ("speakers of Kwakwala"). It is beginning to replace the term Kwakiutl (also spelled Kwagulth, Kwaguhl), which is the name of one particular tribe, though the word has been used to refer to a number of related peoples and communities inhabiting the central coast of British Columbia and northern Vancouver Island. The efforts toward adopting the term Kwakwaka'wakw stem from dissatisfaction with using the name of a single tribe to describe a much larger compendium of associated tribes.

Historically, Kwakwaka'wakw ceremonials widely influenced those of other Northwest Coast groups.

In general, in the art, beings are depicted with rounded, elongated heads; blank, staring eyes with well-defined sockets; and strongly sculpted mouths. Facial features tend to be strictly

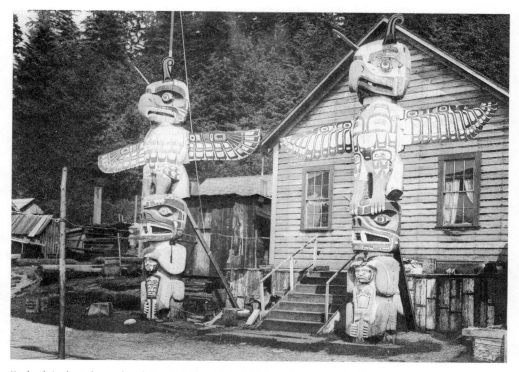

Kwakwa̱ka̱'wakw poles, each with (top to bottom) *Thunderbird*, *Bear* and *Human* holding a *Copper* at the village of Alert Bay, British Columbia. EDWARD S. CURTIS PHOTO, NAC C-003107

differentiated rather than fluid. Depictions of beings tend to be somewhat realistic and recognizable. Decorative elements may be complex, including elaborate but not necessarily continuous formline designs, in strong and often varied colours. Facial contours and other features may be distinguished by the application of colour, rather than the use of depth.

The three-dimensional art often features pieces added on to the main body, such as wings, fins or beaks. Artists also add movable pieces to their work, particularly in the production of *masks*. Double and triple *transformation masks* are a good example of their innovation and engineering. Most of the largest masks in existence are Kwakwa̱ka̱'wakw designs.

Thunderbird sits atop some Kwakwa̱ka̱'wakw totem poles. In the myth time, one group of Kwakwa̱ka̱'wakw people made a deal with Thunderbird; in repayment for his aid during a time of crisis, they agreed to honour his image above all others. Thunderbird remains a very popular image.

Nuxalk (Bella Coola)

The Nuxalk were traditionally rather isolated in their rugged environment, 120 kilometres (90 miles) inland from the Pacific Ocean. They speak a language dialect unique to themselves and

also developed some distinctive artistic styles, such as the use of teardrop and leaf motifs. Nuxalk artists usually create facial features that are rounded and bulbous. Large, solid U-shaped decorative elements are often prominent.

At the time of European contact, Nuxalk villages were not reported to have free-standing monumental poles on display. Apparently, they started to carve *totem poles* sometime after contact. The Nuxalk adopted and modified artistic practices from their neighbours, but they are renowned as innovative story and myth tellers.

Northern Cultures (Haida; Haisla; Heiltsuk, formerly Bella Bella; Tlingit; Oweekeno; Tsimshian, including Gitxsan, Nisga'a and Coast Tsimshian)

The coastal cultures of northern British Columbia and southern Alaska do not share a common language, but they do share related traditions of art, mythology, song, dance and ceremony. The northern tribal groups had a high degree of formality and social organization that led to the development of some of the most elaborate and complex—and to many observers, the most impressive—artistry to be found on the Northwest Coast.

Totem poles originated with the northern cultures, but have now spread to all regions of the Northwest Coast. On northern poles, *humans* appear smaller than other beings to symbolically emphasize the superiority of the supernatural world. A restrained use of colour is a common feature.

The work of various northern groups historically displays similarities of style, as these neighbouring nations influenced each other's artistic practices. Northern tribes also developed the most advanced conventions of formal abstraction in the region. Tlingit geometric abstractions, used in box, basket and blanket designs, are good examples of northern abstraction.

In general, faces tend to be well rounded and more naturalistic than those of the southern traditions. Eyes are prominent, often with sculpted lids and pupils. Human portraits are usually handsome, with balanced, sculpted features; wide, high cheekbones; broad mouths; and well-defined ovoid eyes.

Figures are often fluid and interconnected. Small beings are frequently embedded as space-fillers in designs featuring larger figures. These smaller figures may or may not be relevant to the story or *crest* depicted by the design.

Haida art features large heads, particularly wide eyebrows, prominent, slightly protruding ovoid eye sockets, and finely edged eyelids. Body parts of various creatures typically intermingle and flow in what is sometimes referred to as "visual punning." *Argillite* carving is almost the exclusive domain of Haida artists, because the primary source of the stone is a single quarry on Haida Gwaii. Delicate and intricate argillite items were produced to satisfy non-Native demands for curios; argillite carvings are the original Northwest Coast souvenir.

Tlingit art sfeatures round faces, relatively small noses, and wide-lipped open mouths. The Tlingit imported many objects from the Tsimshian. Particularly strong associations with *shamans* are common in traditional Tlingit art.

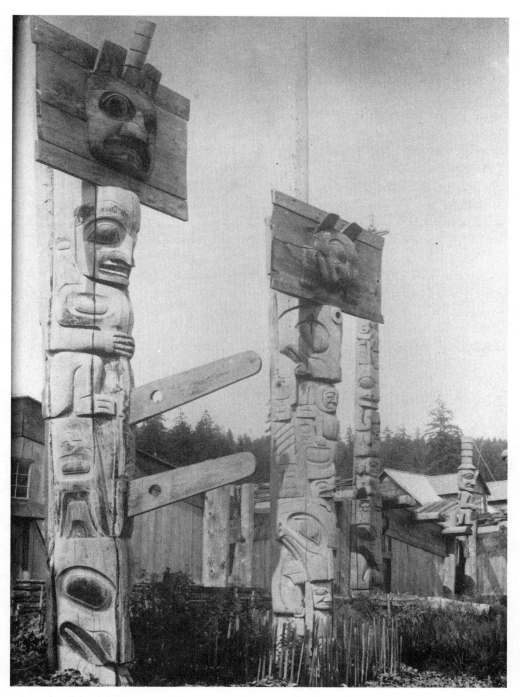

Poles at the village of Skidegate, Haida Gwaii, c. 1912. JOHN BOYD PHOTO, NAC PA-060839

Tsimshian styles often juxtapose figures of dramatically different sizes to add variety and to increase visual interest. Poles, for example, often feature rows of small human figures wedged between much larger supernatural beings. *Masks* may feature solid bands of colour across the eye socket region.

The Haisla, Heiltsuk and Oweekeno were once grouped with their northern or southern neighbours and incorrectly labelled Southern Tsimshian or Northern Kwakiutl. Although these designations are inaccurate because the cultural groups are separate, aspects of their art and culture reveal the influence of major traditions from both directions.

Heiltsuk artists were famous for their fine bent-corner *boxes*, *canoes* and carved implements such as *spoons* and ladles. Variations of the northern formline style developed, featuring light, narrow, fluid lines, open backgrounds, and extensive use of finely executed bilateral symmetry. Eyes feature flattened orbs and precise accentuating rims.

The Haisla traditionally occupy a transitional territory between the northern groups and the Kwakwaka'wakw. Their art is very closely related to that of neighbouring Tsimshian groups and offshore Haida. Many older masks have quite naturalistic faces. Objects and designs are very finely executed and formlines are relatively thin, resulting in a refined and delicate appearance. The *basketry* is typically basic, utilitarian and undecorated.

The Oweekeno occupy land north of Kwakwaka'wakw territory. Their art shows the influence of northern groups but is more strongly associated with that of the Kwakwaka'wakw. In turn, the Oweekeno influenced the Kwakwaka'wakw, who obtained the rights to many myths and *crests* from them through marriage and war. Oweekeno *basketry*, like that of the Haisla, is usually basic, utilitarian and undecorated.

Today, contemporary Northwest Coast Native artists are among the most visible cultural heroes and leaders of their societies. Many successful artists accept responsibility for apprenticing emerging artists, serving as mentors for individuals both from within and from outside their own clans. They also participate in and contribute to ceremonial events, doing their part for the future of their communities.

Selected Bibliography

Anderson, E. N., ed. *Bird of Paradox: The Unpublished Writings of Wilson Duff.* Vancouver: Hancock House, 1996.

Beck, Mary Giraudo. *Shamans and Kushtakas: Northwest Coast Tales of the Supernatural.* Seattle: Alaska Northwest Books, 1991.

Beck, Mary L. *Heroes and Heroines in Tlingit-Haida Legend.* Seattle: Alaska Northwest Books, 1989.

Boas, Franz. *The Mythology of the Bella Coola Indians.* The Jesup North Pacific Expedition Publications, Vol. 1, Part 2. Reprint, New York: AMS Press, 1973.

Brodzky, Anne, Rose Danesewich and Nick Johnson, eds. *Stones, Bones and Skin: Ritual and Shamanic Art.* Toronto: artscanada/The Society for Art Publications, 1977.

Brown, Steven, ed. *The Spirit Within: Northwest Coast Native Art from the John H. Hauberg Collection.* Seattle: Seattle Art Museum, 1995.

Bruchac, Joseph. *Native American Animal Stories.* Golden, Colorado: Fulcrum Publishing, 1992.

Bruggmann, Maximilien, and Peter R. Gerber. *Indians of the Northwest Coast.* New York: Facts on File Inc., 1987.

Burland, Cottie. *North American Indian Mythology.* Toronto: Hamlyn Publishing Group Ltd., 1965.

Cameron, Anne. *Daughters of Copper Woman.* Vancouver: Press Gang Publishers, 1981.

Clark, Ella. *Indian Legends of the Pacific Northwest.* Berkeley: University of California Press, 1963.

Clark, Karin, and Jim Gilbert. *Learning by Doing: Northwest Coast Native Indian Art.* Victoria: Raven Publishing, 1987.

Duffek, Karen. *A Guide to Buying Contemporary Northwest Coast Indian Art.* Vancouver: University of British Columbia Museum of Anthropology, 1983.

Emmons, George T. *The Basketry of the Tlingit and the Chilkat Blanket.* Sitka, Alaska: Friends of the Sheldon Jackson Museum/The Sheldon Jackson Museum, 1993.

Gunther, Erna. *Art in the Life of the Northwest Coast Indians.* Seattle: Superior Publishing, 1966.

Halpin, Marjorie M. *Totem Poles: An Illustrated Guide.* Vancouver: University of British Columbia Press, 1981.

Hawkins, Elizabeth. *Indian Weaving, Knitting, Basketry.* Vancouver: Hancock House, 1978.

Hawthorn, Audrey. *Kwakiutl Art.* Seattle: University of Washington Press and Vancouver/Toronto: Douglas & McIntyre, 1967.

Holm, Bill. *Northwest Coast Indian Art: An Analysis of Form.* Seattle: University of Washington Press and Vancouver/Toronto: Douglas & McIntyre, 1965.

Inverarity, Robert Bruce. *Art of the Northwest Coast Indians*. Berkeley: University of California Press, 1950.

Jensen, Doreen, and Polly Sargent. *Robes of Power: Totem Poles on Cloth*. Vancouver: University of British Columbia Press, 1993.

Jilek, Wolfgang G. *Indian Healing: Shamanic Ceremonialism in the Pacific Northwest Today*. Vancouver: Hancock House, 1982.

Jonaitis, Aldona. *Art of the Northern Tlingit*. Seattle: University of Washington Press and Vancouver/Toronto: Douglas & McIntyre, 1986.

Jonaitis, Aldona, ed. *Chiefly Feasts: The Enduring Kwakiutl Potlatch*. New York: American Museum of Natural History; Seattle: University of Washington Press and Vancouver/Toronto: Douglas & McIntyre, 1991.

Jonaitis, Aldona. *From the Land of the Totem Poles: The Northwest Coast Indian Art Collection at the American Museum of Natural History*. Seattle: University of Washington Press and Vancouver/Toronto: Douglas & McIntyre; New York: American Museum of Natural History, 1994.

Jones, Joan Megan. *The Art and Style of Western Indian Basketry*. Vancouver: Hancock House, 1982.

Kew, Della, and P. E. Goddard. *Indian Art and Culture of the Northwest Coast*. Vancouver: Hancock House, 1997.

Kirk, Ruth. *Wisdom of the Elders: Native Traditions on the Northwest Coast*. Vancouver/Toronto: Douglas & McIntyre, 1986. (Published in the United States as *Tradition and Change on the Northwest Coast*. Seattle: University of Washington Press, 1986.)

Kramer, Pat. *Totem Poles*. Vancouver: Altitude Publishing Canada Ltd., 1998.

Lamb, Andy, and Phil Edgell. *Coastal Fishes of the Pacific Northwest*. Madeira Park, B.C.: Harbour Publishing, 1986.

Lévi-Strauss, Claude. *The Way of the Masks*. Trans. Sylvia Modeski. Seattle: University of Washington Press and Vancouver/Toronto: Douglas & McIntyre, 1982.

Macnair, Peter L., Alan L. Hoover and Kevin Neary. *The Legacy: Tradition and Innovation in Northwest Coast Indian Art*. Vancouver/Toronto: Douglas & McIntyre, 1984.

Macnair, Peter, Robert Joseph and Bruce Grenville. *Down from the Shimmering Sky: Masks of the Northwest Coast*. Vancouver/Toronto: Douglas & McIntyre and Vancouver Art Gallery; Seattle: University of Washington Press, 1998.

Malin, Edward. *A World of Faces: Masks of the Northwest Coast Indians*. Portland, Oregon: Timber Press, 1978.

Malin, Edward. *Totem Poles of the Pacific Northwest Coast*. Portland, Oregon: Timber Press, 1986.

McDowell, Jim. *Hamatsa: The Enigma of Cannibalism on the Pacific Northwest Coast*. Vancouver: Ronsdale Press, 1997.

Maud, Ralph, ed. *The Salish People: The Local Contribution of Charles Hill-Tout*. Vol. 2, The Squamish and the Lillooet. Vancouver: Talonbooks, 1978.

Neel, David. *The Great Canoes: Reviving a Northwest Coast Tradition*. Vancouver/Toronto: Douglas & McIntyre, 1995.

Neel, David, and Andrew Hunter. *David Neel: Living Traditions*. Kamloops, B.C.: Kamloops Art Gallery, 1998.

Paterek, Josephine. *Encyclopedia of American Indian Costume*. New York: W. W. Norton & Co., 1994.

Reid, Martine J. *Myths and Legends of the Haida Indians of the Northwest*. Santa Barbara, CA: Bellerophon Books, 1998.

Scott, Andrew. "Revering the Robust Arbutus." *Georgia Straight*, 10-17 December, 1998.

Smyly, Carolyn and John. *Those Born at Koona.* Vancouver: Hancock House, 1994.

Steltzer, Ulli, and Robert Bringhurst. *The Black Canoe: Bill Reid and the Spirit of Haida Gwaii.* Vancouver/Toronto: Douglas & McIntyre, 1995.

Steltzer, Ulli, and Catherine Kerr. *Coast of Many Faces.* Vancouver/Toronto: Douglas & McIntyre and Seattle: University of Washington Press, 1979.

Stewart, Hilary. *Looking at Indian Art of the Northwest Coast.* Vancouver/Toronto: Douglas & McIntyre and Seattle: University of Washington Press, 1979.

Stewart, Hilary. *Looking at Totem Poles.* Vancouver/Toronto: Douglas & McIntyre and Seattle: University of Washington Press, 1993.

Sturtevant, William C. (general editor) and Wayne Suttles (volume editor). *Northwest Coast.* Vol. 7 of *Handbook of North American Indians.* Washington: Smithsonian Institution, 1990.

Thom, Ian M. *Robert Davidson: Eagle of the Dawn.* Vancouver/Toronto: Douglas & McIntyre and Vancouver Art Gallery, 1993.

Turner, Dolby Bevan. *When the Rains Came and Other Legends of the Salish People.* Victoria: Orca Book Publishers, 1992.

Turner, Nancy J. *Food Plants of Coastal First Peoples.* Vancouver: University of British Columbia Press, 1995.

Vickers, Roy Henry, and Brian Payton. *Spirit Transformed: A Journey from Tree to Totem.* Vancouver: Raincoast Books, 1996.

Wallace, James, and Pamela Whitaker. *Kwakiutl Legends.* Vancouver: Hancock House, 1989.

Wardwell, Allen. *Tangible Visions: Northwest Coast Indian Shamanism and Its Art.* New York: Monacelli Press, 1996.

Wilson, Douglas, and Leslie Drew. *Argillite: Art of the Haida.* Vancouver: Hancock House, 1980.

Woodward, Arthur. *Indian Trade Goods.* Portland, Oregon: Binford & Mort, 1965.

Zona, Guy. *The Soul Would Have No Rainbow If the Eyes Had No Tears.* New York: Touchstone, 1994.